MEDIEVAL AND RENAISSANCE
TREASURES
FROM THE V&A

MEDIEVAL AND RENAISSANCE
TREASURES
FROM THE V&A

EDITED BY

PAUL WILLIAMSON AND PETA MOTTURE

V&A PUBLICATIONS

This book is published to accompany the exhibition
Medieval and Renaissance Treasures from the V&A
at the following venues:

Art Gallery of Ontario, Toronto
23 June–7 October 2007

Norton Museum of Art, West Palm Beach
20 October 2007–6 January 2008

Speed Art Museum, Louisville
22 January–20 April 2008

The Metropolitan Museum of Art, New York
20 May–17 August 2008

High Museum of Art, Atlanta
11 October 2008–4 January 2009

Millennium Galleries, Sheffield
29 January–24 May 2009

First published by V&A Publications, 2007

V&A Publications
Victoria and Albert Museum
South Kensington
London SW7 2RL

Distributed in North America by
Harry N. Abrams, Inc., New York

ISBN: 978 1 85177 526 2
Library of Congress Control Number
2007924504

10 9 8 7 6 5 4 3 2 1
2011 2010 2009 2008 2007

A catalogue record for this book is available
from the British Library.

Designed by Nigel Soper
New V&A photography by Christine Smith,
V&A Photographic Studio

In addition to the work of the editors, Glyn Davies,
Stuart Frost and Kirstin Kennedy have contributed
catalogue entries, which are initialled accordingly.

We are also grateful to Caroline Bulloch, Alexandra
Corney, Mandy Greenfield, Ken Jackson, Christine
Smith, Nigel Soper, Katy Temple and Monica Woods.

Front jacket illustration: Dragon Aquamanile (see no.4)
Back jacket illustration: The Martelli Mirror (see no.29)
Frontispiece: Wild Man and Woman stained and painted
glass (detail, see no.27)

Printed in Hong Kong

V&A Publications
Victoria and Albert Museum
South Kensington
London SW7 2RL
www.vam.ac.uk

CONTENTS

FOREWORD

THE VICTORIA AND ALBERT MUSEUM'S collection of medieval and Renaissance art and design is among the finest and most comprehensive in existence, with certain categories – such as medieval ivory carvings – being particularly rich. This is due principally to two factors. First, the South Kensington Museum (in which the V&A was originally contained) was uniquely placed, in the third quarter of the nineteenth century, to benefit from the ongoing dispersal of the contents of many cathedrals, churches and private collections in Europe. As is described in Paul Williamson's essay, many treasuries were broken up following the French Revolution in 1789; and during the Napoleonic Wars early in the nineteenth century numerous religious houses were suppressed and demolished. By 1850 much of this material – goldsmiths' work, enamels, ivories, textiles, stained glass and sculpture – had come into the hands of a small group of dealers and collectors (several of them in England), and the nascent Museum, able to call on government for considerable sums for acquisitions, took advantage of this. Likewise, the political situation in Italy and Spain just after the middle of the nineteenth century released numerous important works of art onto the market. But the availability of material does not in itself guarantee the creation of a great collection.

The second factor that contributed to the Museum's later pre-eminence in these areas was the expertise of its staff. The first curator, John Charles Robinson, had the good fortune to be in the right place at the right time, but his extraordinary energy coupled with advanced connoisseurship and precocious expertise ensured that he was able to build up the collections in a remarkably sustained and effective campaign of acquisition during the 1850s and 1860s. By about 1890 the foundations had been laid, and by this time even the great museums of Berlin and New York – whose glory days were about to arrive – needed to work hard and long to emulate the South Kensington record.

Since Robinson's day the V&A has continued to add medieval and Renaissance works of art to its collections, and throughout the twentieth century new acquisitions of the first importance were made by succeeding generations of knowledgeable curators. In addition to adding to the collections, it is vitally important that the works of art are shown to their best advantage and made fully accessible to a wide audience – many of whom will not be familiar with the material. Our medieval and Renaissance collections are at the heart of the Museum, and it is essential that we give them the high profile they deserve. A completely new suite of galleries, opening in late 2009, will be devoted to the Middle Ages and Renaissance, and in the run-up to this, the opportunity to tour key pieces has been taken. It is our hope that this special exhibition will not only educate and give enjoyment, but will also inspire those visiting it to come to London to see the new galleries at the V&A and to develop a passion for the great works of consummate craftsmanship displayed therein.

MARK JONES *Director, Victoria and Albert Museum*

INTRODUCTION

Peta Motture

THE WORKS IN THIS BOOK are instantly recognizable as extraordinary masterpieces of artistic achievement. But they would also originally have carried a multiplicity of meanings, and they now offer us a window onto the world in which they were created. In addition to their primary purpose – be it to pour water (no.4), to inspire devotion (no.13) or to act as an official gift (no.23) – their materials, decoration and forms would have signalled the status of those who owned or paid for them, as well as the 'God-given' talents of their makers.

The redisplay of the V&A's Medieval and Renaissance Galleries provides a unique opportunity to examine how European art and design articulated attitudes to identity, material wealth and spiritual beliefs. The objects shown here will play a role in telling these stories, alongside the full range of the Museum's collections, including furniture and tapestries, paintings and large-scale architectural sculpture. By exploring artistic production from AD 300 to 1600, the new displays will offer a fresh insight into European cultural history, from the decline of the Roman Empire and the early spread of Christianity, to a time of increased wealth and confidence created by discovery and conquest in new worlds.

Despite the significant shifts and changes that took place during these 1,300 years, the objects themselves demonstrate how many of the same concerns endured. In those selected here, such continuities are drawn out by connecting works from across the timescale under three key headings – Status and Display, Piety and Devotion, and the Secular World. The placement of each object, however, was not a foregone conclusion. The panel from the ivory Nicomachi-Symmachi diptych (no.1), for example, could have appeared in all three sections. Embellished with scenes of pagan devotion, the panels were probably designed to commemorate a marriage. About 1,100 years later, a bronze mirror-back apparently played a similar role for the Martelli family of Florence (no.29). Its classically inspired decoration emphasizes that marriage was first and foremost intended to forge alliances and to continue the family line, as in the Roman period.

The reuse of classical or traditional imagery could bring with it the powerful air of legitimizing new regimes (no.2). In fact, the destruction or survival of an artefact might depend on the associations it carried and whether it was possible to adapt and update it (see pp.4–13; no.23). Recognizable forms and rituals could ease the transition to new beliefs and ways of life, though the origins of a particular design may, in time, have lost their significance. The power of certain imagery did not, however, go unnoticed. The international language of heraldry was ideal for making grand and easily recognized statements. The monumental *stemma* (coat of arms) of the French king, René of Anjou, made around 1470 by Luca della Robbia (V&A: 6740–1860), which once graced the exterior of a villa belonging to the Pazzi family of Florence, would have been clearly seen by all who approached the house, and underlined the family's international connections. Heraldry worked equally well on small-scale objects for personal use (nos 26, 31–2) or to identify the pious donor of church furnishings. In some

instances these personal identifiers were more discreet, recognizable only to a particular audience, such as the clergy or acolytes who used the objects (no.18), or to the owners and their educated guests (nos 28–30).

Even intimate objects like a bronze statuette (no.30), housed within the private domain of the scholar's study, were intended to be shared with those invited to enter that inner sanctum. However, the notion of privacy was very different from today, as most rooms in a wealthy household were also used to receive visitors, either for business or pleasure. In fact, the division between apparently opposing concepts was far from clear-cut. The interconnection between the sacred and the secular, for instance, appears in many guises. The form of the Early Renaissance portrait bust, though inspired by classical precedents, evolved from head reliquaries like that of St Antigius (no.21). Non-religious imagery frequently adorned objects made for a devotional context (no.5). But the sacred-secular relationship is particularly redolent in the exquisitely carved Virgin and Child by Veit Stoss (no.8) – an object of religious devotion, but probably made to adorn a collector's cabinet. Though different in style and context, this statuette is nonetheless reminiscent of two earlier examples carved in ivory (nos 13, 17), highlighting how the cult of the Virgin endured across the centuries.

In addition to imagery, materials themselves carried associations: glass and ivory denoted purity, rock crystal eliminated poisons, and pearls embodied preciousness and truth (no.12). They also played a role in defining the form of the works of art themselves. The size and shape of the elephant tusk, for example, determined the scale and elegant sway of the French Virgin and Child (no.17). The pose was carried over into large-scale stone statues, influencing the style of late thirteenth- and fourteenth-century architectural sculpture that decorated the façades of churches and cathedrals. Similarly, the small-scale, fine-grained wood of the box tree enabled Stoss to create the thinly carved, flying drapery of his statuette. The sculptor was equally successful on a larger scale in limewood, a less accommodating material that demanded extraordinary skill to conjure works of such fluid elegance. In the words of the twelfth-century Abbot Suger of Saint-Denis (himself repeating the saying of Ovid): '*materiam superabat opus*' – 'the workmanship surpassed the material'.

This transformation of natural materials by artifice is another recurring theme, and at times the mutation was astonishing. Sand became precious glass and enamel (nos 14, 26), while clay could be fashioned, fired and decorated to create sculptures or luxurious and exotic ceramics (nos 9, 34). The availability of material and the demands of the market led to centres specializing in particular types of production. The Limoges workshops made vast quantities of enamels from the late twelfth century (no.7); alabasters from Nottingham were exported throughout Europe in the late fourteenth and fifteenth centuries; while Faenza, Pesaro and Urbino were among the centres renowned for Renaissance maiolica (nos 31–2). The often-complex processes required to bring these works to fruition could be dangerous and uncertain, and generally involved a number of people. Hubert Gerhard's altarpiece (no.10), which took three years to make, required the skills of a range of artisans, including bricklayers (to construct the furnace for melting the copper alloy), founders, goldsmiths and the specialist craftswomen who scratch-brushed the surface of the sculptures and washed them down with beer and water.

Though medieval craftsmen both attached their names to works and gained high reputations, the status of the artist increased significantly from the fifteenth century, when works became sought-after purely as the product of a particular maker. The 1492 inventory of the Medici Palace in Florence, taken after the death of Lorenzo the Magnificent, lists paintings by Uccello and sculptures by Donatello, among others. Like Antico (see no. 30), artists were also employed at the princely courts, where their duties could range from repairing antiques to undertaking diplomatic missions, from advising on purchases to providing designs for other craftsmen.

Above all, artists were admired for their *ingegno*, their creativity and ability to produce novel ideas. Leonardo was a paragon in this respect, a man whose interests went far beyond art, encompassing scientific exploration and investigation of natural phenomena, as demonstrated by the notebook shown here (no. 35). His talents were, nonetheless, recognized by the famous sixteenth-century painter and biographer Giorgio Vasari as 'bestowed by God … and not acquired by human art'. The notion that such skills were divinely bestowed was long established, although it had soon become a topos, not universally upheld. In his treatise for craftsmen, *On Divers Arts*, for example, the twelfth-century monk Theophilus had similarly acknowledged the 'gifts that God' had 'deigned to grant freely' to him, while in contrast his French contemporary, Hugh of Saint-Victor, viewed human work as 'mechanical, that is, adulterate'.

As this selection of objects clearly shows, the distinction between art and artefact was blurred, even during the Renaissance. Alongside the works of the great artists, which spoke of the taste and wealth of the patron, were other luxury goods that sent similar messages: the striking jewellery (no. 12), the elaborate candlestick (no. 9) or collectible metalwork (no. 11). The decoration on the maiolica service associated with Isabella d'Este (no. 32) was effectively a painting in miniature, and was held in equally high esteem. The fashioning of the artist, therefore, added considerable value to what might otherwise be comparatively modest goods.

Medieval and Renaissance Treasures from the V&A creates an opportunity to view these artefacts in different ways: as exceptional works of art, and as the material evocation of the culture in which they were produced. By highlighting the continuities across the ages relating to artistic production and the meanings these objects embodied, unexpected interconnections and recurring interests are revealed. The V&A's new Medieval and Renaissance Galleries will similarly aim to unravel these potentially complex messages. Arranged chronologically, these same objects will illuminate a variety of narratives about style, use, the makers and their markets, as well as highlighting both continuity and change. Some will be juxtaposed with other works to explore these stories: from medieval metalwork (no. 5) and personal devotion (no. 17), to the notion of Renaissance identity (no. 33) and the style known as International Mannerism (no. 11). Others will be shown individually (nos 1, 2, 7, 14, 35), a testament to the skill and mastery of those who made them.

LIKE A PHOENIX FROM THE ASHES:
THE SURVIVAL OF MEDIEVAL AND RENAISSANCE WORKS OF ART

Paul Williamson

EVERY MEDIEVAL OR RENAISSANCE work of art has a story to tell. Many were created as carriers of a narrative, while others acted as single images to be prayed to or simply admired for their beauty and craft. But beyond this, beyond the reason they were created in the first place, they also have their own histories, their own biographies. In some cases, these 'lives' of objects – often including travel, reuse, modification and a multitude of owners – become inextricably linked with the creation of new works of art, works of art that owe their appearance and sometimes their very existence to their predecessors. These cycles of creation-circulation-dislocation-reinvention lie behind the survival of a good number of the antiquities we now find in the great museums of the world.

The conditions that allowed works of art to pass through the generations – unscathed, if fortune favoured them – have no set pattern. Some objects were kept safely in one place for centuries, and became available to collectors only in the recent past; others were divorced from their original context at an early date and have spent the intervening years passing from one owner to the next, often being re-employed in radically different roles. It is the fate of most institutions (either ecclesiastical or secular) and of most dynasties (whether political or familial) to come to an end eventually and for their belongings to be dispersed. None of these belongings was created for a museum, despite the fact that many are now viewed as 'heritage' items, so it is invariably of interest to look into the vicissitudes behind an object's provenance and to ask why it is where it is.

The slow decline of the Roman world brought with it, in due course and at variable rates across Europe, an unsurpassed quarry of buildings and works of art

to those who occupied the lands of the Empire. Vast numbers of architectural treasures were lost, either through neglect and decay or through destruction at the hands of invaders, and much was simply buried under what came afterwards. The Italian town of Pisa was typical in this respect, and an eighteenth-century writer lamented that much Roman work was submerged as foundations beneath the medieval Duomo: 'an infinity of antiquities condemned by barbarism to an eternal night … Ancient Pisa has furnished the materials for modern Pisa.'[1] Those buildings that survived usually owed their continuing existence to being translated into different use – in Rome, and elsewhere in Italy, many temples were converted into churches, or at least offered their sites for new religious foundations. If demolished, the classical buildings might be plundered for their raw materials – marble revetments, columns, capitals and other architectural features. These *spolia* were often clearly visible, built into the walls of the new edifices, and even Roman sculptural reliefs were set into Christian and secular buildings (pl.1).

The reuse of classical building materials was at first intensely pragmatic and practical: it was available and saved new quarrying. By the eighth century, however, Roman materials were also being employed as symbols of civic authority and, through their quality and richness, to link those using them with the power and tradition of Rome. Charlemagne, crowned Holy Roman Emperor in 800, was famously at pains to emulate the courtly splendour of Late Antique Rome and to equal the Byzantine opulence of the emperors in Constantinople, and he piously revered the memory of the Early Christian Church. His biographer Einhard recorded that 'this explains why he built a cathedral of such great beauty at Aachen, decorating it with gold and silver, with lamps, and with lattices and doors of solid bronze. He was unable to find marble columns for his construction anywhere else, and so he had them brought from Rome and Ravenna.' Another writer, Notker, was even clearer about Charlemagne's aims: 'He conceived the idea of constructing on his native soil and according to his own plan a cathedral which should be finer than the ancient buildings of the Romans.'[2] Not only did Charlemagne bring columns from Italy, but his scribes and illuminators copied classical texts and illustrations. His ivory workshop went further still. In addition to aping the style of sixth-century ivories (see no.2), several of the book covers actually utilized consular diptychs, planed down, for their raw materials, and a good number of

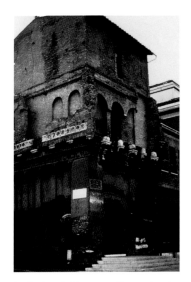

1 The Casa di Crescenzio, Rome, showing the use of classical Roman *spolia* on a 12th-century building.

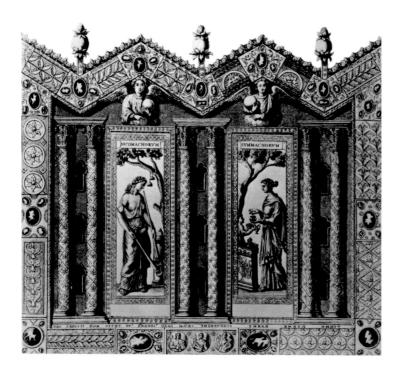

2 Photomontage from engravings in
E. Martène and U. Durand, *Voyage
littéraire de deux religieux bénédictins de la
Congrégation de Saint Maur* (Paris, 1717),
showing the Nicomachi-Symmachi
diptych incorporated into the shrine at
Montier-en-Der.

other secular Late Antique ivories owe their survival to reuse in a Christian context,
including the leaf of the Anastasius diptych (no. 23).

So Charlemagne and many of the medieval rulers, bishops and abbots who
followed him acted as saviours and guardians of Roman antiquities. The twelfth-
century Abbot Suger of Saint-Denis is perhaps the best known of these,
incorporating many ancient objects into new settings and openly appreciating
their antiquity and the beauty of the materials (see p. 15). The Nicomachi-
Symmachi diptych (no. 1) was employed as the doors on a Late Romanesque shrine
at Montier-en-Der (pl. 2), and it is ironic that these Late Antique ivories ultimately
survived the destruction following the French Revolution, whereas most of the
later enamels and goldsmiths' work on the shrine did not. It is also known that
some medieval churchmen had a high regard for classical sculptures on a larger
scale, and one of these – Henry of Blois, Bishop of Winchester – even imported
several pieces to England in the mid-twelfth century. [3] It is likely that such Roman

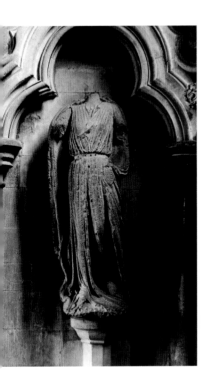

3 Female figure, possibly a personification of *Ecclesia* (the Church); limestone; English, about 1230–40. Winchester Cathedral.

sculptures, now lost, acted as models for the highly classicizing Gothic sculpture of the early thirteenth century (pl.3).

The presence of these ancient works of art in a new Christian context did not necessarily guarantee their security, as the monastic and church treasuries were of course extremely vulnerable to being plundered. Sometimes this was done for good reason, as when in the tenth century St Aethelwold broke up and sold the vessels in his church in order to feed those suffering in a famine: it was recorded that the saint declared 'that he could not endure the continued existence of dumb metal whilst man, who was created in the image of God and redeemed by the precious blood of Christ, died of starvation and want'.[4] In England, Viking incursions had earlier stripped many of the churches of their riches, and after the Norman Conquest in 1066 several of the most precious reliquaries and numerous liturgical vessels were melted down or sent abroad. For the history of art, this was undoubtedly disastrous, but there is the consolation that destruction often leads to the need for replacement, and one might take the view that the splendid sequence of English twelfth-century ivories and goldsmiths' work might not have been produced, were it not for the previous losses. The sacking of Constantinople during the fourth crusade in 1204 was a barbarous act unworthy of its Christian perpetrators, but it at least ensured that a good number of Byzantine treasures of the first importance reached Venice and northern Europe, where they have been safely preserved ever since (pl.4). Had they remained in Constantinople, they would undoubtedly have been lost at the fall of the Byzantine capital to the Turks in 1453.

Likewise, the series of fires that afflicted cathedrals during the twelfth and thirteenth centuries brought forward magnificent buildings to replace them, with ambitious and innovative sculptural schemes and new reliquaries filling the treasuries. The conflagration of 1194 that destroyed the main body of Chartres Cathedral, for instance, was directly responsible for the construction of the magnificent existing building, with its breathtaking stained glass and extensive sculptural schemes on the transepts. Chartres Cathedral had always been dedicated to the Virgin, and there were many who saw the fire as divine intervention, giving a clear signal that a grander building was needed to honour her.[5]

For Britain, the suppression of the monasteries and pilgrimage sites in the years following 1536, and the Injunctions of the Reformation ten years later, were

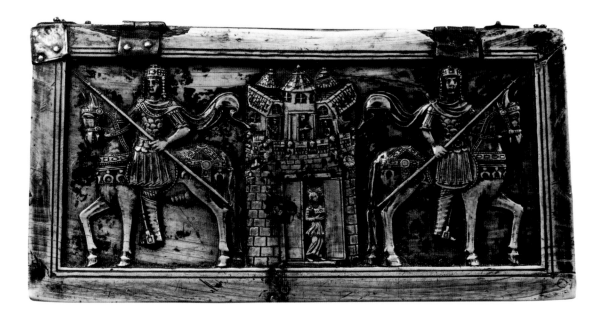

4 Casket with Emperors and
Hunters (showing the lid); ivory,
with pigmentation; Byzantine
(Constantinople), probably 11th-century.
Trésor de la Cathédrale de Troyes.

to be the most image-threatening events of all. A sustained campaign against images
and relic-worship, at first heretical but slowly gaining official sanction, gathered
momentum in the first half of the sixteenth century and led ultimately to the
destruction of the vast majority of religious works of art. The prominent shrines
of St Edward and St Thomas in the great monastic cathedrals of Westminster and
Canterbury were among the first to go, stripped of their numerous gems and
cameos and sent to the royal mint for melting down: 26 cartloads of treasures were
taken from Canterbury Cathedral alone, and all the other monasteries suffered the
same fate.[6] Some idea of the extraordinary wealth of the holdings may be gained
by recourse to the many inventories drawn up before the Dissolution of the
monasteries, which tantalizingly list the precious items, often in some detail.[7]

After the monasteries had succumbed, attention turned to the parishes and
their churches. An injunction of 1547 decreed that clergy and people were 'to take
away, utterly extinct [extinguish] and destroy all shrines, covering of shrines, all
tables, candlesticks, trindles or rolls of wax, pictures, paintings and all other
monuments of feigned miracles, pilgrimages, idolatry, and superstition; so that
there remain no memory of the same'.[8] It is a wonder that anything survived at all,

but some parishioners took it upon themselves to hide, rather than destroy, liturgical items or images; one of these, Roger Martin of Long Melford in Suffolk, recorded how he had saved a small altarpiece and kept it in his house, and which he hoped 'my heires will repaire, and restore again, one day'.[9] Other works, such as English alabaster carvings, were sent or sold abroad, both before and after the Reformation. Fortunately, Catholic countries – Italy, Spain, France and large parts of Germany and the Netherlands – escaped the iconoclasm of reforming Protestantism, and of course the production of often magnificent secular works of art continued unabated everywhere. But these countries were to have their own troubles a few centuries later, when the dispersal of works of art from religious foundations reached unprecedented levels.

The French Revolution in 1789 and the Napoleonic Wars that followed in the early nineteenth century released a flood of medieval and Renaissance works of art onto the market. French royal foundations were closed down, and numerous churches were secularized in France and the adjoining occupied cities in the Rhineland – especially Cologne – and the southern Netherlands. The widespread dispersal of the treasuries occurred at a time when an informed interest in the Middle Ages and Renaissance was taking root among wealthy collectors and helped to feed the nascent collections that would be established around the middle of the nineteenth century, including the South Kensington Museum (today's Victoria and Albert Museum).[10] Objects that had been safely preserved for hundreds of years, under the protection of the Church, finally moved from ecclesiastical to secular – and, it is to be hoped, ultimately more secure – ownership. The leaf of the Anastasius diptych (no. 23), for instance, which had found protection among the liturgical items in the treasury of Liège Cathedral, eventually found its way to London in 1871. Notwithstanding the violent disjunction of these acts, there is something not entirely inappropriate about this change – especially as the great national museums are now viewed by many as cathedrals of culture.

It was not just the monastic and cathedral treasuries that were emptied. Huge quantities of stained glass were taken from the windows of cloisters and churches in France and the Rhineland at this time, the vast majority of it coming to England in the first instance; this was inserted into churches previously stripped of their English medieval glass, and into the neo-Gothic private chapels of the gentry.[11]

Later on, nearly as much stained glass was made available through the actions of restorers, who would often take out damaged panels and replace them with new work. On the secular side, the actions of the French Revolution made available numerous tapestries and other works of art from châteaux throughout France, which ultimately became especially sought-after by newly rich American collectors for the furnishing of their mansions in the early twentieth century. Many of these have now passed to museum collections in the United States.

The last great exodus of European works of art took place in Italy – and, to a lesser extent, Spain – as a result of political upheaval in the middle of the nineteenth century. The reunification of Italy led in many cases to secularization and a reduction in the numbers of religious foundations, which subsequently encouraged sale and demolition. The South Kensington Museum was in an excellent position to benefit from these circumstances, with funds available for acquisition and a brilliant first curator in John Charles Robinson. There are several letters from Robinson on his travels abroad testifying lucidly to the clear, but often dangerous, opportunities that arose. In December 1860, for instance, on closing a deal to acquire the Gigli-Campana collection in Rome, he left Naples 'with an escort of Papal Dragoons and with our revolvers ready in our hands in expectation of Brigands who have just reappeared'; and in October 1866 he wrote from Spain: 'I am very anxious to get authority to buy … *now is the time* – this country is in semi-revolution, money has disappeared … and whatever there is to be sold is in the market for a fraction of what would have been formerly asked.'[12] This all makes present-day curatorial practice sound rather dull, and Robinson comes across as more of an Indiana Jones than the scholarly connoisseur he undoubtedly was. He was also not insensitive to the wider historical issues and to the importance of context in an appreciation of art. Having acquired Bartolommeo Buon's great relief for the tympanum of the Misericordia church in Venice (pl. 5) in 1882, he wrote:

5 Madonna della Misericordia (Virgin of Mercy) by Bartolommeo Buon; Istrian stone; Italian (Venice), about 1441–5. V&A: 25–1882.

the Municipality of Venice has taken no steps, or only feeble, perfunctory ones, to prevent the destruction or alienation of innumerable archaeological and artistic treasures of the city; and when unavoidable demolitions occur, no effort is made to acquire precious architectural fragments and details for the vaunted museum. Thus the ancient abbey of

'La Misericordia', one of the well known churches of the city, which for years past has stood empty and desecrated, has just lost its principal sculpturesque decorations, and these, as they were openly in the market for sale, I have secured for this country … The tympanum of the Misericordia is intrinsically a work of high merit and importance, but it had infinitely greater significance in its original place. It is indeed a page torn from the record of Venetian art.[13]

By purchasing the sculpture, Robinson at least ensured that, although taken from Venice, it was not lost to the world.

The objects in the V&A were acquired, in the early days, to act as exemplars of good design and to encourage contemporary practitioners to learn from their technical and artistic excellence. The Museum was therefore set up to serve a purpose that was ultimately not dissimilar to that of the earlier treasuries from which many of the medieval and Renaissance objects came. There, too, objects provided inspiration for contemporary craftsmen, ensuring that the forms of antiquity were carried forward and made relevant for the present. There are numerous examples of this process of continuity and change, an artistic 'laying-on of hands' where works of art have been reinterpreted to fit a new purpose, and they illustrate most strikingly the value of objects moving from one place to another. One example may suffice. From the Early Middle Ages, Sassanian and Byzantine silks had found their way north, as imperial or ecclesiastical gifts, and must have been utilized in a variety of ways – in a funerary context, within graves, for vestments, for lining the insides of luxury boxes, and so on. The designs on these silks frequently took the form of animals and birds, and a particularly popular choice was the senmurv, a legendary beast with the head and forepaws of a lion or dog, the wings of an eagle and the tail feathers of a peacock. A typical example, now in the Museum's collections, is said to have been found in a reliquary in the church of Saint-Leu in Paris (pl.6). Fabrics such as these seem to have played an inspirational role in the design of two gilt-bronze ewers of the early twelfth century, one now in the V&A (no.4), the other in Vienna (pl.7). Both ewers were probably produced in that crucible of Early Romanesque creativity, the Meuse Valley, but – like the silks that influenced their appearance – they themselves were transported

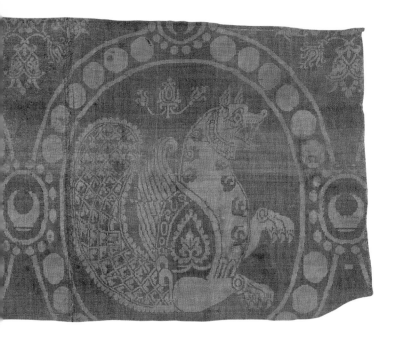

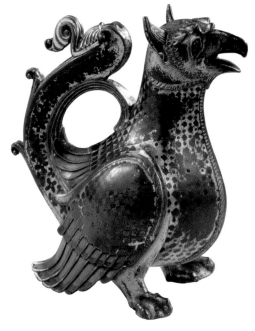

elsewhere, and the griffin ewer had almost certainly reached the imperial collections at Vienna by the early eighteenth century. Rather unexpectedly, it served as the model for a porcelain chocolate pot and cover in 1744–9 (pl.8), and the story does not end there.[14] The chocolate pot in turn was copied just after the middle of the nineteenth century by the London silversmith George Fox, who transformed it into a claret jug and translated it back into metal (pl.9).

 That particular visual history stretches across more than a millennium. It illustrates the power of objects with a strong aesthetic appeal to inspire the work of future generations, and exemplifies the importance of the past as a reservoir of ideas and creativity. Church treasuries, distinguished private collections of prince and gentry, the major museums – all have played a part in giving homes to great medieval and Renaissance works of art and ensuring that their often striking visual qualities continue to exercise a powerful influence on us all.

6 Woven silk fragment showing a senmurv; probably Byzantine, 9th century. V&A: 8579–1863.

7 Griffin aquamanile; gilded copper alloy with niello and silver overlay; probably Mosan, about 1120. Kunsthistorisches Museum, Vienna.

8 Chocolate pot and cover; white porcelain; Austrian (Vienna), 1744–9. V&A: C.7–1968.

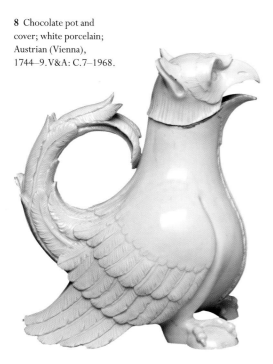

9 Claret jug; silver and parcel-gilt; by George Fox, London, with marks of 1877. V&A: M.20–1986.

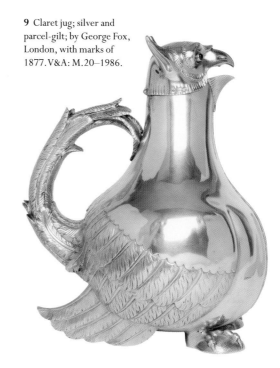

NOTES

1 M. Greenhalgh, *The Survival of Roman Antiquities in the Middle Ages*, London, 1989, p.74

2 Einhard and Notker the Stammerer, *Two Lives of Charlemagne*, translated by L. Thorpe, Harmondsworth, 1969, pp.79, 125

3 P. Williamson, *Gothic Sculpture 1140–1300*, Pelican History of Art, New Haven and London, 1995, pp.48, 113

4 C.R. Dodwell, *Anglo-Saxon Art: A New Perspective*, Manchester, 1982, p.7

5 Williamson (1995), p.37

6 F.A. Gasquet, *Henry VIII and the English Monasteries*, 5th edn, London, 1893, II, pp.387–439

7 For the ivories, see P. Williamson, 'Ivory Carvings in English Treasuries before the Reformation', in D. Buckton and T.A. Heslop (eds), *Studies in Medieval Art and Architecture presented to Peter Lasko*, Stroud and London, 1994, pp.187–202

8 E. Duffy, *The Stripping of the Altars: Traditional Religion in England c.1400–c.1580*, New Haven and London, 1992, p.480

9 D. Dymond and C. Paine (eds), *The Spoil of Melford Church: The Reformation in a Suffolk Parish*, Ipswich, 1992, p.2; see also Duffy (1992), pp.489–92

10 See 'The collecting of medieval works of art', in P. Williamson, *The Thyssen-Bornemisza Collection: Medieval Sculpture and Works of Art*, London, 1987, pp.9–19

11 P. Williamson, *Medieval and Renaissance Stained Glass in the Victoria and Albert Museum*, London, 2003, pp.10, 15 (note 3)

12 J. Pope-Hennessy, *Catalogue of Italian Sculpture in the Victoria and Albert Museum*, London, 1964, I, p.ix; M. Trusted, *Spanish Sculpture: Catalogue of the Post-Medieval Spanish Sculpture ... in the Victoria and Albert Museum*, London, 1996, p.7

13 Pope-Hennessy (1964), pp.342–3

14 J.V.G. Mallet, 'Romanesque into Rococo: the odd case of a Vienna porcelain chocolate pot', *Connoisseur*, August 1969, pp.233–6

STATUS AND DISPLAY

B Y THEIR VERY NATURE, works of art have always been intended for display. Even those made for the glory of God were meant to reflect, by the choice of materials and the skill of their craftsmanship, the prestige of place and donor. Throughout the Middle Ages and the Renaissance the most precious materials were lavished on images and objects for Church and State, for holders of high ecclesiastical office and wealthy private patrons. Some of these objects were ceremonial, others were produced for the delectation of a select few, but they all reveal the aims and aspirations of their first owners.

Many of the earliest ivory carvings of the Christian era were made for presentation. Ivory was a luxury commodity and its use signified the wealth and high standing of the donor, so it is no coincidence that most of the surviving examples can be associated with particular individuals, usually the consuls of Rome and Constantinople in the fifth and sixth centuries (nos 1, 23). When the art of ivory carving was revived at the court of the Emperor Charlemagne at the end of the eighth century, it was done in full knowledge of the material's use in antiquity, as Charlemagne and his entourage sought to present an image of imperial majesty to compare with that of the Caesars (no. 2). The Church was not slow to see the value of ostentatious displays of power,

and the princes of the ecclesiastical realm – the great bishops and powerful abbots of the most influential cathedrals and monasteries – became the most important patrons of the best medieval craftsmen. They commissioned beautiful accoutrements of office, including croziers (no. 6), mitres, processional crosses, rings and liturgical combs, and ensured that the bodies and the relics of the saints were appropriately honoured in jewel-encrusted shrines.

The shrines and reliquaries of the Middle Ages were, of course, the most precious items of all. They were holy in themselves, for what they contained, and their appearance invariably mirrored the importance of their contents. They were meant to elicit awe and devotion in equal measure, and the shrines were often displayed in the place of honour in the church, behind the high altar. The thirteenth-century shrine of St Edward the Confessor in Westminster Abbey, now lost, was described as 'placed on high like a candle upon a candlestick, so that all who enter in the House of the Lord may behold its light'. In some of the most important cathedrals and abbey churches, other places were set aside to act as treasuries, where the most beautiful liturgical items and reliquaries could be seen.

Most of these treasuries no longer exist, having been broken up in times of religious and civil strife, but numerous

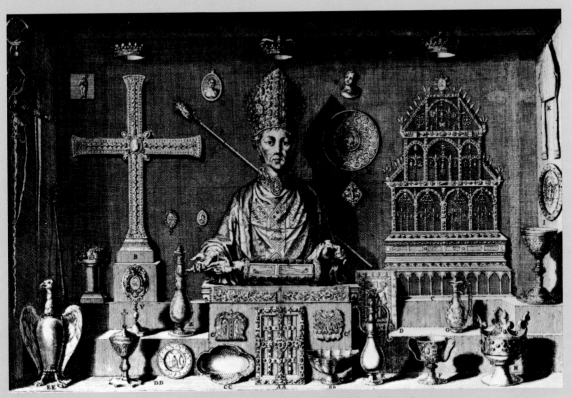

Plate IV from Dom Michel Félibien, *Histoire de l'abbaye de Saint-Denis en France* (Paris, 1706), showing some of the items in the treasury of Saint-Denis.

inventories of the time provide a vivid picture of the wealth of their holdings. The treasury of the royal abbey of Saint-Denis, north of Paris, was especially rich, many of the items having been commissioned by the famous Abbot Suger in the first half of the twelfth century. By the beginning of the eighteenth century it had been ordered into five large cases, and an illustration of one of these gives a clear indication of the range of objects one might expect to find in other treasuries (above). One can imagine the bust of St Antigius (no.21) — essentially a devotional object and included in the book in that category — being displayed in similar fashion.

It was a small step from the cathedral treasury to the personal treasury — the *Kunstkammer* — of the Renaissance. The new wealthy class of merchants and bankers in fifteenth- and sixteenth-century Italy, Germany, the Netherlands and France were able to collect on a scale comparable to the medieval churches. They, too, shared the objects they commissioned with others, although the public could not gaze upon the works in their possession. But within this smaller circle of peers the owning of such works — status symbols *par excellence* — still had everything to do with displaying wealth, taste and a knowledge of the past. PW

THE SYMMACHI PANEL

Late Antique (Rome); about 400

Ivory

V&A: 212–1865; h. 29.6 cm, w. 12.1 cm

 A PRIESTESS, standing beneath an oak tree and waited on by a young attendant, is about to sprinkle on the altar before her the contents of the bowl she is holding. In a scroll at the top of the panel is the inscription 'SYMMACHORUM' ('Of the Symmachi'), which links it with its pair in the Musée national du Moyen Age in Paris. The latter, now much damaged and stained, shows a similar priestess and has the inscription 'NICOMACHORUM' ('Of the Nicomachi'). The panels originally made up a diptych, probably commissioned by one of these patrician families to celebrate either their close association through marriage or a joint devotion to Dionysus. Only the wealthy elite in Late Roman society could afford to order such splendid commemorative ivories, the precursors of the official diptychs that were issued by the consuls of Rome and Constantinople from the early fifth century until 541 (see no. 23).

The diptych was made at a time when the old pagan sects of Rome were being swept aside for Christianity, and the ivory carvers responsible for making it also manufactured panels for Christian patrons. In due course, many of the secular carvings were incorporated into Christian settings, and several owe their survival to this reuse. The Nicomachi-Symmachi diptych was employed as the doors of an early thirteenth-century reliquary shrine in the abbey of Montier-en-Der in France and remained there until the French Revolution in 1789, after which the shrine apparently 'fell prey to fire' and was broken up (see pl. 2). The Nicomachi leaf was thrown down a well, but the Symmachi panel – one of the finest surviving ivories from the Late Antique period – obviously escaped such a violent fate: both were rediscovered just after the middle of the nineteenth century. PW

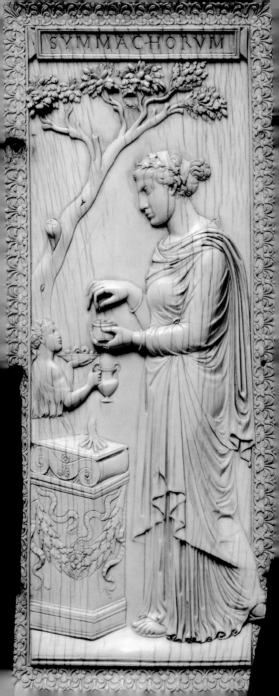

SYMMACHORVM

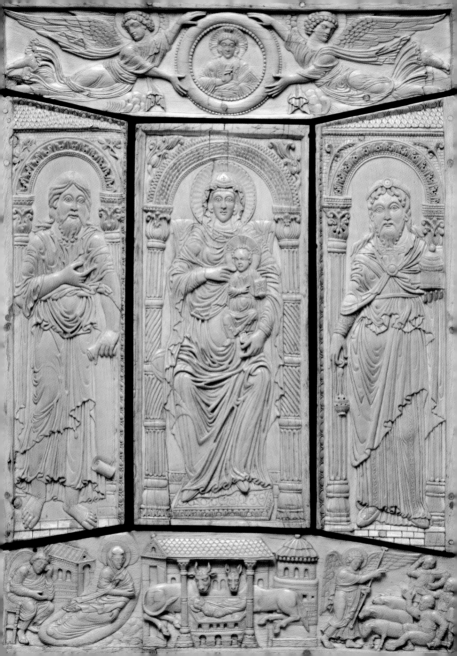

FRONT COVER OF THE LORSCH GOSPELS

Carolingian (Aachen); about 810

Ivory

V&A: 138–1866; h. 38.5 cm, w. 28 cm

 DURING THE MIDDLE AGES book covers were often lavishly embellished with ivory carvings, enamel plaques, intricate goldsmiths' work and jewels. Medieval manuscripts of the Gospels of the New Testament especially were frequently richly illuminated, so it was fitting that their covers should match the splendour of the works they enclosed. These five plaques came from the front cover of the so-called Lorsch Gospels, made for the imperial abbey of the same name; the back cover is now in the Vatican Museums in Rome, and together they are among the largest and grandest ivory medieval book covers to have survived.

The Virgin and Child are shown enthroned between St John the Baptist on the left and the prophet Zacharias on the right, while above is a medallion of Christ blessing, held by angels; the Nativity and the Annunciation to the Shepherds are represented below. This type of five-part book cover was inspired by sixth-century prototypes, and the style of the ivory carving also harks back to Byzantine works of the sixth century, such as the ivories on the Throne of Maximianus in Ravenna. The Emperor Charlemagne, crowned in Rome in 800, was determined to be compared with the emperors of classical antiquity, and he presided over a court where learning and culture were valued and where inspiration was taken from the artistic products of an earlier age. The Lorsch Gospels are one of the most important examples of Charlemagne's Court School and exemplify the 'Carolingian Renaissance'. PW

THE BASILEWSKY SITULA

Ottonian (Milan?); about 980

Ivory

V&A: A.18–1933; h. 18 cm; purchased with the Funds of the Vallentin Bequest
and with the support of the Art Fund

A SITULA IS A HOLY WATER BUCKET, used when the water was sprinkled on the congregation at blessings or 'asperges', and also known as an aspersorium. Ivory examples are extremely rare and were probably made only for special occasions or as gifts for dignitaries of great eminence. One of the inscriptions on this situla states clearly that it was presented to such a figure – 'the august Otto': it is highly likely that this was the Emperor Otto II and that the situla was presented to him on the occasion of his visit to Milan in 980. It is related in style to another ivory situla made in Milan, which was given to the church of Sant'Ambrogio in that city at about the same time. The present situla presumably remained in Italy until the nineteenth century, when it was apparently purchased in Florence and passed through several hands, including the Russian collector Alexander Petrovich Basilewsky and Tsar Alexander III, before entering the collections of the Hermitage Museum in St Petersburg; it was sold by the Hermitage in 1933.

The situla is decorated with 12 scenes from the Passion of Christ, starting on the upper tier with Christ washing the feet of the apostles and ending on the lower register with the scene of the Incredulity of St Thomas. The two heads at each side were pierced to take a handle, and it is likely that a secondary and non-permeable bucket – perhaps in glass or silver – sat within the ivory situla. PW

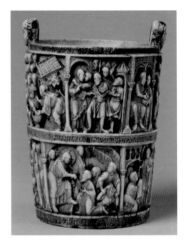

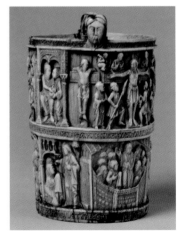

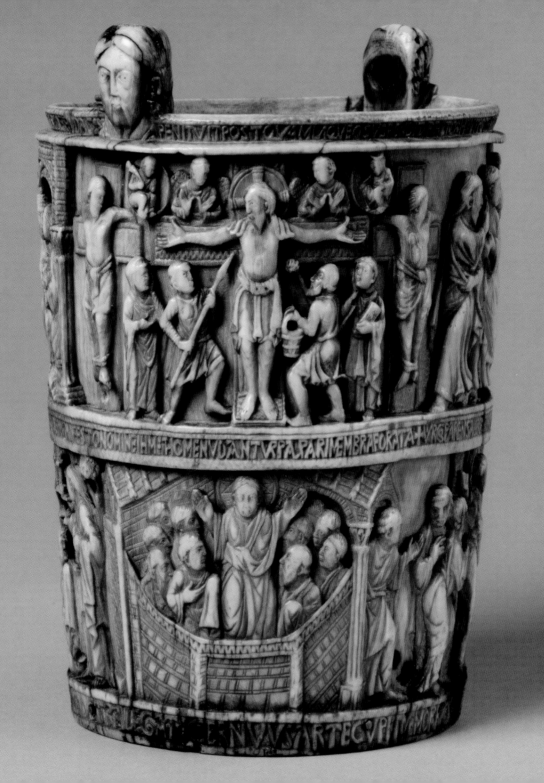

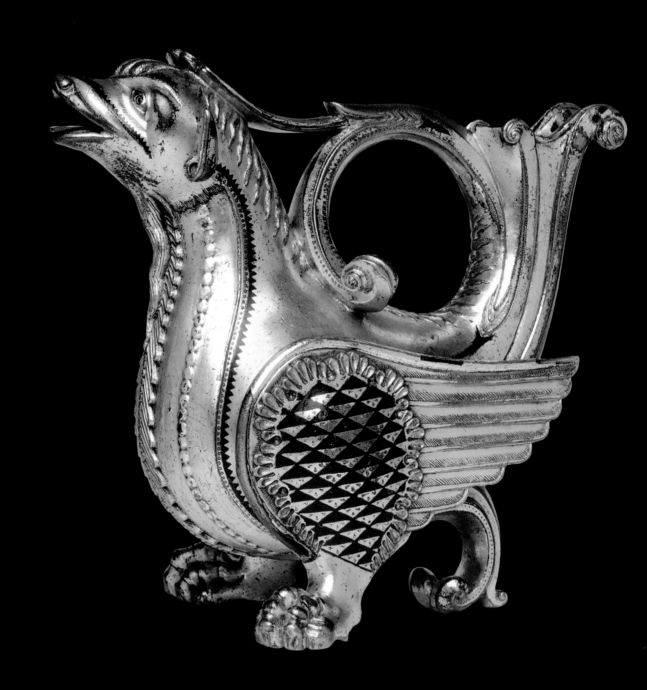

DRAGON AQUAMANILE

Valley of the Meuse; about 1120

Gilded copper alloy with niello (a black metal alloy used to fill incised designs on silver) and silver overlay

V&A: 1471–1870; h. 18.7 cm

 VESSELS FOR WASHING THE HANDS were ubiquitous in the Middle Ages, but from the twelfth century onwards the type of ewer known as an aquamanile (from the Latin *aqua*, for water, and *manus*, for hand) was particularly popular, and was often made in the form of an animal or fantastic beast. This aquamanile, which resembles a dog-headed dragon, is not only one of the most splendid to survive, but is also perhaps the earliest western example. It takes its appearance from the legendary creatures known as senmurvs, sometimes shown on Sassanian and Byzantine silk fabrics that found their way into northern European church treasuries (see pl.6), and may also have been inspired by earlier Islamic prototypes. Another aquamanile, in the form of an eagle-headed griffin and now in the Kunsthistorisches Museum in Vienna (pl.7), closely resembles the London dragon in facture and appearance.

Although ewers of this type were of course functional, being filled through a covered opening and the liquid usually poured through the mouth, they must also have been prized for their sculptural qualities and rich surface treatment. They were made to be turned in the hand and admired, and can thus be seen as direct precursors of the figurative bronzes valued so highly in the Renaissance. The best examples, such as this piece, would have signalled the status and wealth of its owner in no uncertain terms. PW

THREE ENAMELLED PLAQUES

Valley of the Meuse; about 1160

Copper-gilt and champlevé enamel

V&A: M.53, M.53A and M.53B–1988; h. 10.2 cm, w. 10.2 cm (each plaque);

acquired with the support of the National Heritage Memorial Fund and the Art Fund

THE PLAQUES SHOW A MAN on a camel, Samson and the Lion, and the Ascension of King Alexander to the heavens. They were made by the specialist craftsmen of the Meuse river valley. These artists were patronized by important and wealthy churchmen, such as Abbot Wibald of Stavelot, adviser to Emperor Frederick Barbarossa, and Henry of Blois, Bishop of Winchester. Men like this, whose political power was as significant as their religious roles, commemorated themselves through lavish gifts to their churches.

These enamel panels, known as the Rolls plaques (because they were previously in the possession of the Rolls family of Monmouthshire), are particularly interesting for their use of secular imagery within a Christian setting. The plaque showing Alexander the Great's flight in a chariot drawn by griffins would have been immediately recognizable to a medieval viewer, as it was one of the most popular stories of the period – various versions survive from the twelfth century. It is likely that this scene was juxtaposed with one from the Old or New Testaments, as it could be used to symbolize pride or faith.

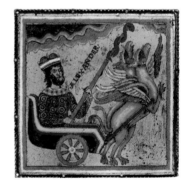

The plaques have sometimes been linked to the great cross erected by the powerful Abbot Suger in the choir of his abbey of Saint-Denis in 1145–7, which was adorned with scenes of Christ's Passion and with others that were believed to prefigure it. A direct connection is unlikely, however, because these and other plaques in the series do not deal solely with the Passion. Nevertheless, there can be no doubt that they would originally have formed part of a major ecclesiastical furnishing, advertising the power and wealth of the church that displayed it, as well as the munificence of the donor. GD

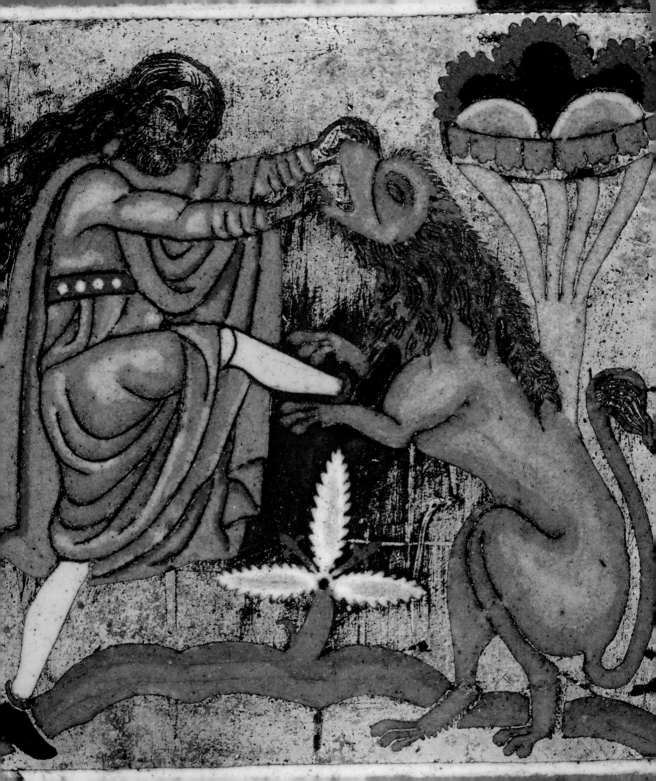

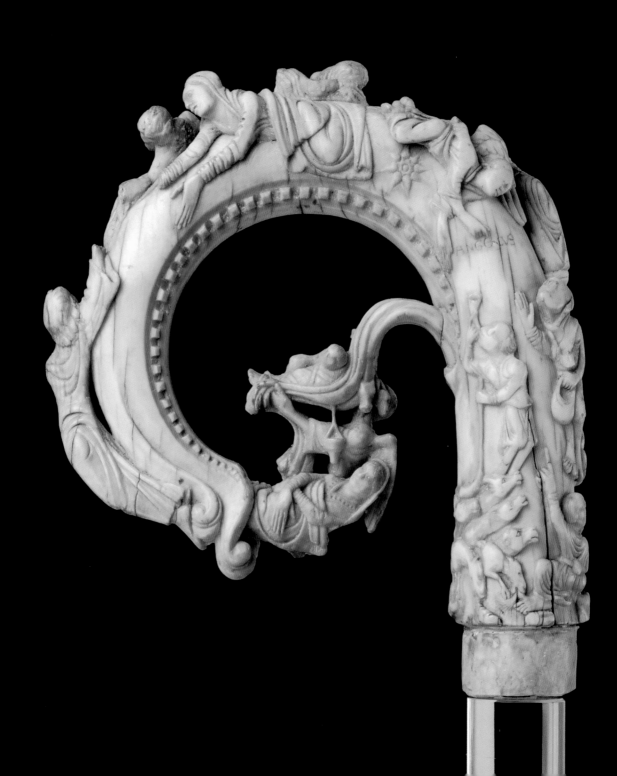

THE ST NICHOLAS CROZIER

English (Winchester?); about 1150–70

Ivory

V&A: 218–1865; h. 11.7 cm, w. 10.5 cm

A CROZIER IS A PASTORAL STAFF used by abbots or bishops as a symbol of their office. This exquisitely carved crozier-head is one the finest surviving examples of medieval ivory carving.

On one side of the shaft is illustrated the Annunciation to the Shepherds, with the angel flying down towards the shepherds and their flock. On the opposite side the carver has depicted the birth of St Nicholas, and placed another scene above showing the infant refusing to take his mother's milk on a fast day, with the father of the saint emerging from the body of the crozier-head. The outer curve shows the young adult Nicholas stretching up, offering coins to the impoverished parents of three daughters, who are shown sleeping in a single bed and who, without Nicholas's intervention, would have been sold into prostitution. A tendril that emerges from the crozier-shaft shows the Nativity of Christ on one side and the Lamb of God (now missing its head) supported by an angel on the other. Christ is thus positioned at the centre of the composition.

The crozier-head has been carved with great skill and ingenuity, successfully incorporating a large number of narrative scenes on a remarkably small and challenging surface. The choice of St Nicholas for three scenes indicates that the crozier was made either for an abbot or bishop who shared the saint's name, or for a high-ranking ecclesiastic in charge of an institution dedicated to him. The quality of the carving could only ever have been fully appreciated by those people who were able to handle the crozier and inspect it closely. SF

RELIQUARY CASKET OF ST THOMAS BECKET

French (Limoges); about 1180–90

Gilt-copper and champlevé enamel on a wooden core

V&A: M.66–1997; h. 29.9 cm, w. 30.5 cm, d. 11.4 cm; acquired with the support of the
National Heritage Memorial Fund, the Art Fund and other benefactors

 THE MAIN IMAGE on this casket commemorates one of the key moments in the medieval dispute concerning the relative status of Church and State. It depicts the moment when Archbishop Thomas Becket was murdered in Canterbury Cathedral on 29 December 1170 by four knights and a subdeacon (nicknamed 'the evil cleric'). Becket, who had been seen as a proud and overly elegant man, was immediately perceived as a saint, a perception enhanced by the discovery that beneath his rich robes he was in the habit of secretly wearing a hair shirt in penitence. The casket, made about 10 years later, shows a potent visual image of his saintly death. Many of the details have been altered – there are only three knights, one pointing, another drawing his sword and the last attacking Becket's head. Becket is shown, not clinging to a column as texts describe, but in prayer before an altar set for Mass, with chalice, cross and consecrated host. Above, we see his funeral. His soul is represented being taken into heaven twice – once in the martyrdom scene, and again in a triumphant image at the upper right.

In death, Becket triumphed over the King, Henry II, who in remorse became one of the first patrons of the new saint's cult. Becket, canonized in 1173, was a saint of international importance, and the enamel workshops of Limoges produced large numbers of caskets to hold relics associated with him. This example is probably the earliest, and is certainly the largest and finest. It has been suggested that the reliquary was used to house the relics of Becket taken by his friend Benedict to Peterborough Abbey in 1177, since by the eighteenth century it was in the possession of a prominent family in the area. GD

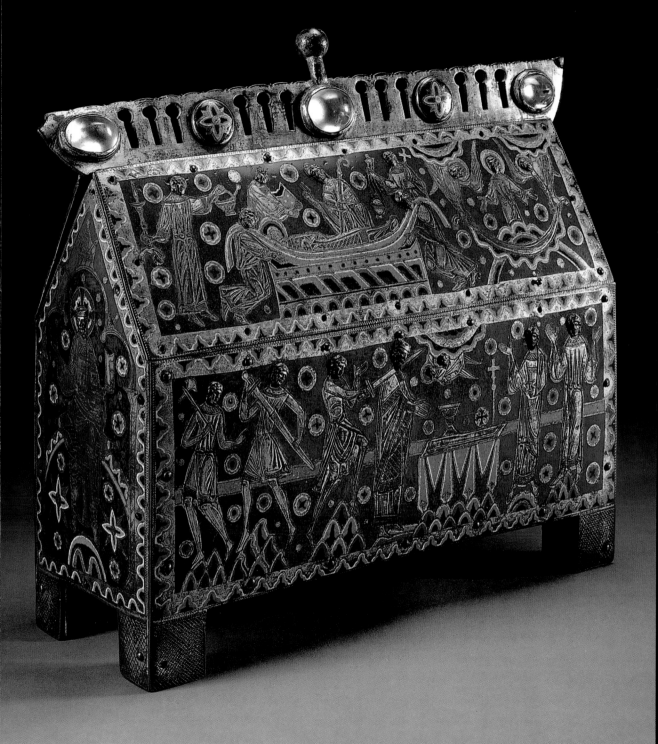

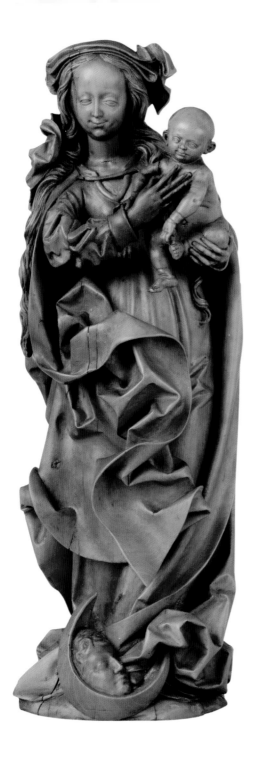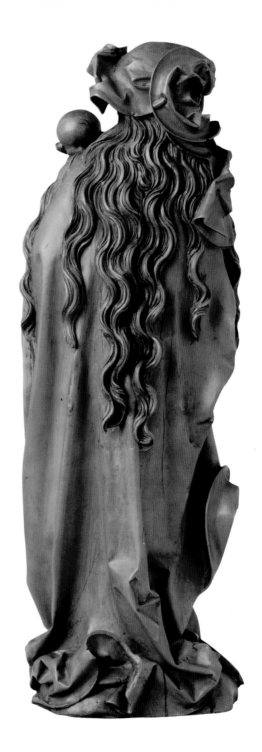

THE VIRGIN AND CHILD

By Veit Stoss (about 1445–1533)

German (Nuremberg); 1500–05

Boxwood

V&A: 646–1893; h. 20.3 cm

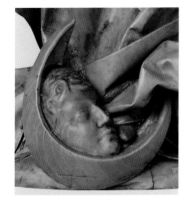

THE PRESENCE OF A CRESCENT MOON with a male face at the feet of the Virgin indicates that this statuette was intended to be identified with the Woman of the Apocalypse described in the Book of Revelation (XII, 1–2). The relevant passage describes 'a woman clothed with the sun, and the moon under her feet'. Albrecht Dürer produced several engravings of the Virgin and Child standing on a crescent moon, the first dated to around 1499, and Stoss was probably aware of Dürer's print.

The figure is beautifully carved in the round. The Virgin's hair falls over her shoulders and spirals down her back. Her gown and cloak have deep angular folds, which give a sense of movement, as if the garments are billowing in a breeze. Traces of gilding remain. The small dimensions of this piece and the virtuosity of the carving suggest that it was made for a collector and is an early example of autonomous small-scale sculpture. A statuette of the Mourning Virgin by Veit Stoss is preserved in the Cleveland Museum of Art, and other works recorded in his studio are also assumed to have been of a small scale. This evidence indicates that Stoss was supplying a range of such statuettes for a newly emerging connoisseur-collector's market, and that this sculpture was valued as much for the quality of its craftsmanship as for its religious subject matter.

Stoss's work was appreciated internationally. He obtained commissions from Italian clients, the King of Portugal and from the Emperor Maximilian I at Innsbruck. The sixteenth-century Italian artist Giorgio Vasari was highly impressed by one of Stoss's larger sculptures, praising 'its drapery with most subtle carving, so soft and hollowed, and as it were paper-like, and with such a fine arrangement of the folds, that nothing more wonderful is to be seen'. SF

CANDLESTICK

French (Paris?); probably 1547–59

Lead-glazed earthenware

V&A: 261–1864; h. 32 cm

THIS CANDLESTICK IS ONE OF fewer than a hundred surviving examples of so-called 'Saint-Porchaire' work, and its rarity is matched by the obscurity of its origins. The label 'Saint-Porchaire' appears in sixteenth-century inventories and became current again in the nineteenth century. It refers to the soft, white clay found in the village of Saint-Porchaire in western France that was used for these pieces. However, the lack of archaeological evidence, coupled with the eclectic sophistication of the designs, strongly suggests that these ceramics were actually made in the vicinity of the French court. The classically inspired frowning masks and truncated figures (herms), strikingly combined with winged cherub-heads and standing children wearing protective coral necklaces, recall the innovative artistic trends encouraged by Francis I (d. 1547) and Henry II (d. 1559) at their residences in Fontainebleau and Paris.

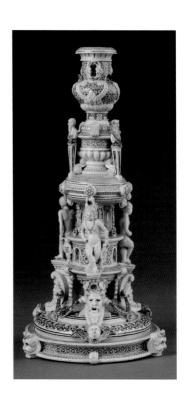

Did this candlestick ever hold a candle? Although its form and intricate interlace-pattern inlay recall metalwork and the imposing structures of Renaissance architecture, the fragile material from which this piece was made meant that it must have been rarely used and always handled with great care. The ingenuity of the craftsman in creating the illusion of a robust object is one reason it would have been valued by its owner. Perhaps another is its possible status as a royal gift. The shields around the candlestick bear the Royal Arms of France and a deliberately ambiguous device of Henry II (this consists of an H superimposed with two letters, which can be read either as C for his wife Catherine de Medici, or D for his mistress Diane de Poitiers). A high proportion of Saint-Porchaire ceramics carry French royal devices and this, coupled with a lack of inventory evidence, implies that they may not have graced the King's apartments, but instead been treasured as royal gifts by his subjects. KK

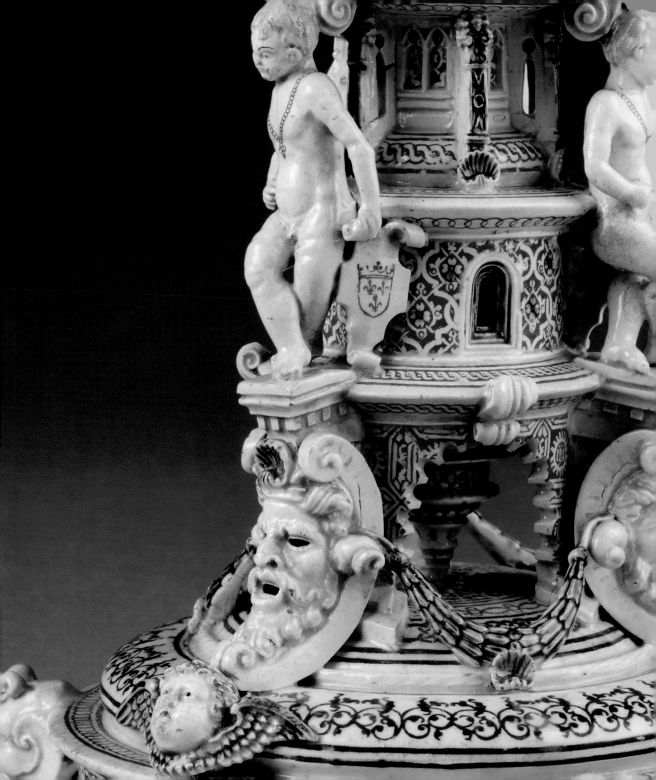

TWO STANDING PROPHETS

By Hubert Gerhard (about 1550–1620)

German (Augsburg); 1581–4

Gilt-bronze

V&A: A.25–1964; h. 33.9 cm / V&A: A.26–1964; h. 35.8 cm; bequeathed by

Mr George Weldon

THESE FIGURES OF PROPHETS were part of an altar memorial made for Christoph Fugger (1520–79), a member of the extraordinarily wealthy Augsburg banking family. When Christoph died, a large sum of money was allocated from his estate to pay for a memorial appropriate to his position. The monument was located in the church of St Magdalena in Augsburg. The commission was given to Hubert Gerhard although, like most sculpture, the making of the altar was a collaborative process, involving a number of craftsmen and women.

The altarpiece consisted of two bronze reliefs and six statuettes mounted on a red and white marble retable, with two bronze kneeling angels below. A relief of the Resurrection was placed centrally, flanked by pairs of standing prophets, seated prophets and small angels holding the Instruments of the Passion; all of these bronzes were bequeathed to the Museum in 1964 (see left). The relief showing the Ascension, which surmounted the altar, has been missing since the eighteenth century.

The choice of Gerhard was significant. Along with several other northern European artists he had spent time in Italy, where he learnt from the work of Giovanni Bologna, a Flemish sculptor employed by the Medici grand dukes in Florence. Gerhard was able to bring knowledge of the latest ideas and developments from Italy to Augsburg. However, the taste of his patron apparently also played a part in the altarpiece design: the Italianate classicism of the figure style was combined with the more traditional, high-relief treatment favoured in the north, as seen in the Resurrection panel. SF

STANDING CUP IN THE FORM OF A NAUTILUS SHELL

By Paul Aettinger the Elder (1574–1619)

South German (Regensburg); about 1590

Silver-gilt with silver decoration

V&A: M.424–1956; h. 35.5 cm; given by Dr W.L. Hildburgh

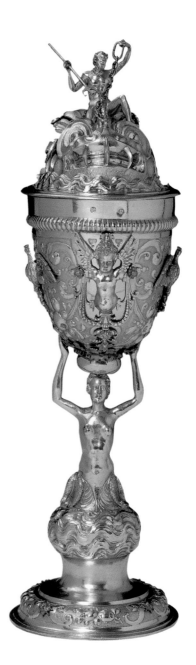

 THE MOVEMENTS OF THE NAUTILUS intrigued medieval and Renaissance commentators. In his 1611 Italian–English dictionary, John Florio, following Pliny the Elder, explained that it was a boat-like creature, which 'useth certaine broad finnes …, both for wings to flie with, and as sailes to flote vp and downe the water'. This curious perception, coupled with the pearly beauty of the spiral-shaped shell, fascinated sixteenth-century European collectors anxious to secure novel objects. They bought specimens imported from Indonesia, which they often had mounted on elaborate stands of precious metal.

However, on the standing cup here, which is inspired by this exotic shell, nothing is quite as it seems. The natural sheen of the nautilus's carapace is reproduced in gilded silver, and while the shell is presented as a cup, its delicacy and preciousness indicate that it was likely to have been displayed, rather than used, at table. This triumph of the silversmith's art and ingenuity was evidently preserved as a family or institutional treasure for, unusually, it has not suffered the fate of much silverware that was melted down and recycled. Guests would have admired the lid with the sea god Neptune riding a fish-like monster; the nautilus itself sails beneath the waves. Meanwhile the base, in the form of a mermaid, continues the maritime theme while elegantly supporting the shell-vessel. The silver eagles and winged putto applied to the shell are incongruous in this context, and may have held significance for the unknown owners. KK

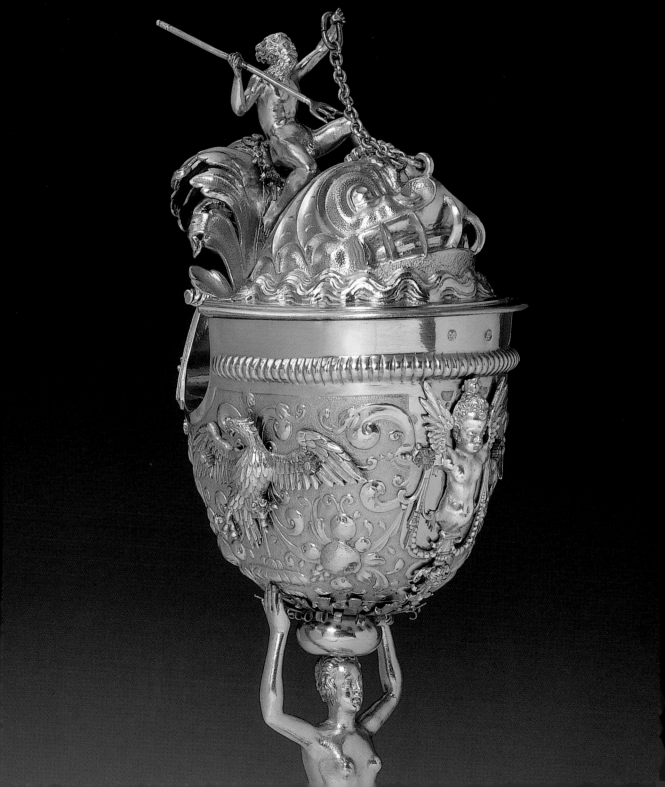

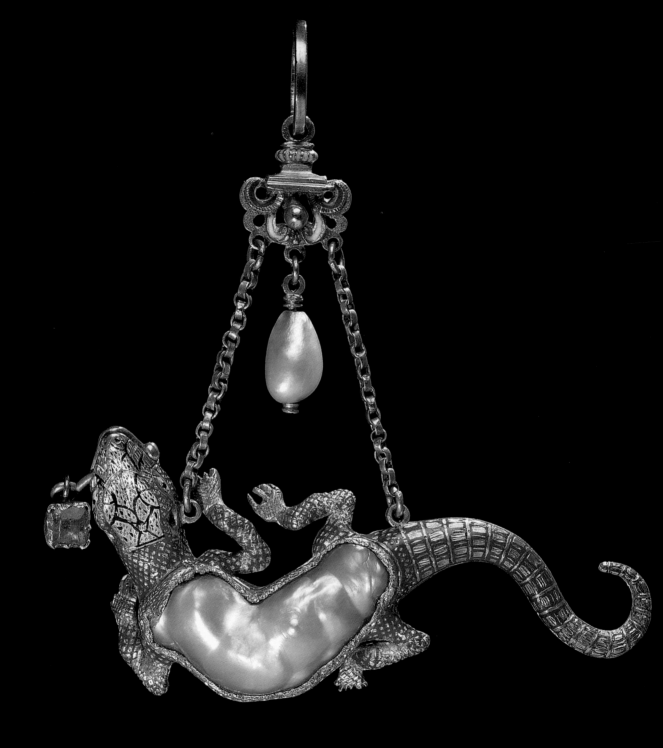

SALAMANDER PENDANT

Western Europe; late 16th century
(the emerald probably a 19th-century addition)
Enamelled gold, set with pearls and an emerald

V&A: M.537–1910; h. 7.1 cm, w. 5.7 cm; Salting Bequest

PEARLS, CONSIDERED TO BE MORE PRECIOUS than diamonds in the thirteenth and fourteenth centuries, returned to the height of fashion in the later sixteenth century because of imports from the New World. Although the taste was always for white pearls, irregular-shaped specimens were as prized as perfectly spherical ones, and came to be termed 'baroque' (from the Spanish *berrueco*, the unappealing facial wart they were said to resemble). Baroque pearls presented the jeweller with an opportunity to test his skill by adapting an object formed by nature to the requirements of Renaissance fashion. The vogue for setting these pearls into mounts perhaps began in southern Germany, but rapidly spread across Europe, and this salamander-shaped pendant is a rare and beautiful example of the craft. The pendant cannot be confidently associated with any particular centre, however: it exemplifies the difficulty of separating the work of different countries in the Late Renaissance, and the term 'International Mannerism' is often used to overcome this problem.

Worn dangling from a long neck-chain at waist level, or pinned to a billowing padded sleeve, this jewel may have been an expensive love token given to a man or a woman. Since classical times, salamanders were thought to live in fires and have the power to extinguish flames; this belief was conveniently adapted to symbolize the condition of the ardent lover and his or her beloved. Whoever wore the pendant, however, would have to beware local legislation on the display of wealth. Throughout the sixteenth century, states continued to attempt regulation of citizens' spending, and pearls were targeted as a source of particular expense. The Republic of Venice especially sought to limit their use: in 1599 it was decreed that only married women could wear pearls, and even then only during the initial 15 years of their first marriage. KK

PIETY AND DEVOTION

THE CHRISTIAN CONGREGATION in the Middle Ages and Renaissance was assisted in its public devotion to Christ and the saints by a plethora of images, signs and texts. Inside every church an array of paintings and sculptures aided prayer and made visual the teachings of the Gospels. Sometimes comprehensive cycles of narrative paintings explained the biblical texts, and from the twelfth century onwards stained glass was a popular and colourful vehicle for presenting the stories of the Old and New Testaments as well as showing single iconic images of saints and prophets (nos 14, 20). Numerous sculpted figures were positioned within the church to attract the prayers of the faithful and candles were placed before them, both illuminating the sculptures with flickering light and representing a manifestation, albeit short-lived, of the interconnection between worshipper and saint. The crucifix occupied a central position, either on a large scale – above the choir screen – or on the altar (no. 16), and sculpted or painted altarpieces emphasized the sanctity of the space connected with the dedication of the Mass. Much of this imagery has been swept away from the church interiors of Protestant Europe, but the living tradition can still be seen – largely unchanged – in numerous Catholic churches. The original appearance of many (now vanished) church interiors can also be recovered by way of inventories written before the Reformation, which often list the numerous statues; and medieval and Renaissance illustrations of donors – in manuscripts and stained glass especially – frequently show them praying before an image of their patron saint (right).

In the later Middle Ages devotional images were increasingly to be found in the home. Patron or name saints could be called to mind by mass-produced or more expensive statuettes, and many of these were considered to offer protection from misfortune or sinful temptation. St Christopher, for instance, was popularly considered to watch over those who had prayed to a likeness of him on rising in the morning; a well-known saying instructed that 'If you, whoever you are, look on St Christopher's face, on that day you shall not die a bad death' (no. 22). The Virgin Mary, the Mother of Christ, was particular revered as a benign intercessor between those offering prayer and God, and statuettes of her abounded, especially those showing her with the Christ-Child (nos 13, 17). These images of tender motherliness unsurprisingly appealed greatly to women, and were to be found not only in a domestic setting, but also in the convent. By the Gothic period, such single images and little devotional diptychs or triptychs were designed to be

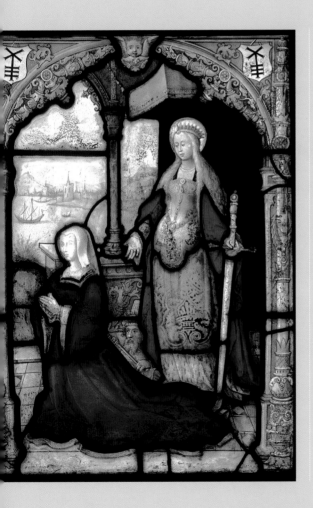

portable, in some cases contained in specially made boxes or cases; they could then be carried during travel and might offer protection on pilgrimage.

During the fourteenth and fifteenth centuries a great variety of small statuettes and devotional images was developed, encouraging different meditative and emotional responses from the viewer. The Pietà, or the Virgin with the Dead Christ (no. 19), was one of the most popular of these. Reliquaries continued to be made in an astonishing range of forms, including those containing the head of a saint, which often resembled portrait busts (no. 21). Here the difficult question of idolatry, a subject repeatedly visited by medieval and later theologians, would have come to the fore. The defence of a sculptor or patron to the charge that a representation of a saint encouraged image-worship was that it was only intended to remind the viewer of the saint, and not to be worshipped in its own right. This distinction would be blurred when the image itself acted as the casing of a saint's relics, and it was precisely this uneasy relationship that led to the reliquaries' widespread destruction at the Reformation. PW

Catherine Boelen being presented by St Catherine; stained and painted glass; Netherlandish (Amsterdam), about 1530.
V&A: 212–1908.

THE VIRGIN AND CHILD

Byzantine; 11th century

Ivory

V&A: 702–1884; h. 32.7 cm

DEVOTION TO THE MOTHER OF GOD gradually increased during the Early Middle Ages and images of her were commonplace in both the East and West (for a French Gothic example, see no. 17). Byzantine sculptural representations of the Virgin were nearly always executed in relief, however, and this is the only known Byzantine ivory figure carved in the round, as a statuette. It shows the Virgin as *Theotokos Hodegetria* – 'the Mother of God showing the Way' (that is, through Christ, whom she holds on her left arm and gestures to with her right hand). Its elongated form and the style of the drapery clearly relate it to eleventh-century marble reliefs from Constantinople. Although fully carved on the back, there is the possibility that the statuette was originally housed within a winged tabernacle, so that in general appearance it resembled a larger-scale version of the Byzantine ivory Virgin and Child triptychs that survive in a number of examples.

The figure's base has been damaged at the front – perhaps when it was removed from its original setting – and repaired, and the head of the Christ-Child is a replacement, perhaps added in the nineteenth century when the statuette was in Italy prior to its acquisition by the Museum. PW

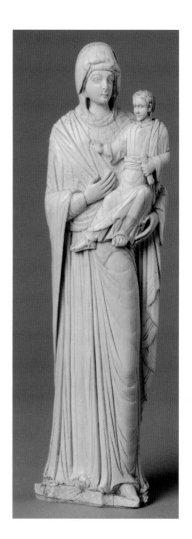

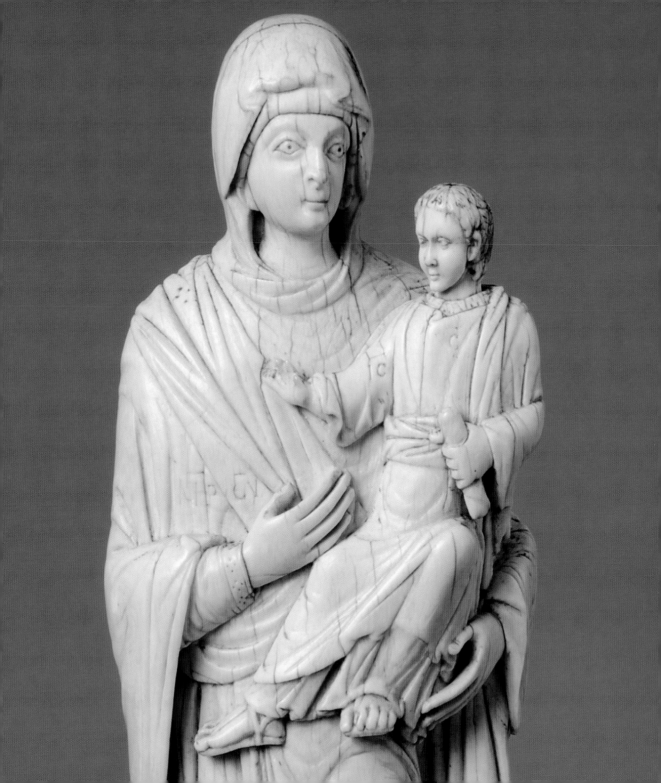

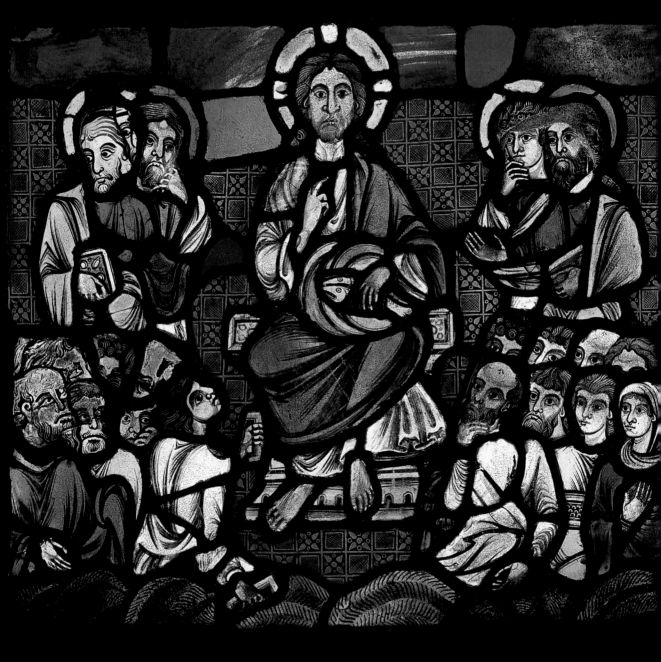

FOUR STAINED GLASS PANELS

French (Troyes); about 1170–80

Pot-metal glass with painted details

V&A: C.105–1919; h. 44.6 cm, w. 51.4 cm / V&A: C.106–1919; h. 43 cm, w. 49.8 cm /

V&A: C.107–1919; h. 44 cm, w. 48 cm / V&A: C.108–1919; h. 46 cm, w. 48 cm;

given by J. Pierpont Morgan, Jr

ONE OF THE MOST IMPORTANT WAYS of telling stories through images in churches was in the use of stained glass. It was a particularly evocative and immersive medium, as it filtered and coloured the light coming into the church, conditioning the space in which the viewer stood. These four panels are from three twelfth-century windows in Troyes, in the Champagne region of France. The two best-preserved panels depict scenes of the Temptation of Christ by the Devil, who is shown in a remarkably lively and colourful manner as a winged being, covered in hair, with serpents protruding from his head like antennae. In the first scene (centre left), he offers Christ some stones, saying, 'If thou be the Son of God command that these stones be made bread' (Matthew 4:3). In the second panel (below left), he carries Christ to the pinnacle of the Temple in Jerusalem. The other panels depict St Nicholas being chosen as Bishop of Myra (top left) and the Feeding of the Five Thousand (opposite).

The panels' style and technique clearly point to the third quarter of the twelfth century. By the nineteenth century they were in the Lady Chapel of Troyes Cathedral, which had only been built in the thirteenth century. It is clear that like much other medieval stained glass, the Troyes panels had been moved about during their history. Indeed, the St Nicholas panel has clearly been widened at the left-hand side with a thirteenth-century foliage border. The glass may originally have been produced for the Romanesque cathedral of Troyes, which was destroyed by fire in 1188, but it is also possible that it could have been moved there from another building nearby – the collegiate church of Saint-Etienne. GD

THE SOISSONS DIPTYCH

French (Paris); about 1280–1300

Ivory, painted and gilded

V&A: 211–1865; h. 32.2 cm, w. 23.4 cm

 DURING THE THIRTEENTH CENTURY there was an increasing emphasis on personal prayer and spiritual life. Faithful Christians were encouraged to imagine the significance and share the sadness of Christ's death, and to pray regularly. This new emphasis encouraged the development of new types of image, and devotional objects were often small and highly detailed, since they were intended to be closely examined and contemplated. This piece is a magnificent example of one particularly common type of devotional object – the ivory double panel or diptych. Its format meant that it was portable and could easily be stood upright, for use during prayer. In a densely packed group of scenes, it tells the story of Christ's Passion and Resurrection, reading – like most ivories of this kind – across both the leaves, starting at the bottom left. Although the image of Christ in Limbo does not appear in the Bible, it is included here and was a central tenet of the Christian faith. Some of the narrative details would have had particular resonance for a contemporary viewer; in the scene where Judas hangs himself, for example, he is shown as having been disembowelled, a common punishment for traitors.

The Soissons diptych is so named because it is said to have come from the abbey of Saint-Jean-des-Vignes in that city. There can be no doubt, however, that it is a product of one of the best ateliers of ivory carvers in Paris in the second half of the thirteenth century. This diptych and the others closely associated with it took their inspiration from the new architectural and decorative vocabulary of cathedral façades, such as Notre-Dame in Paris, and were highly influential in carrying the new style to markets further afield. GD

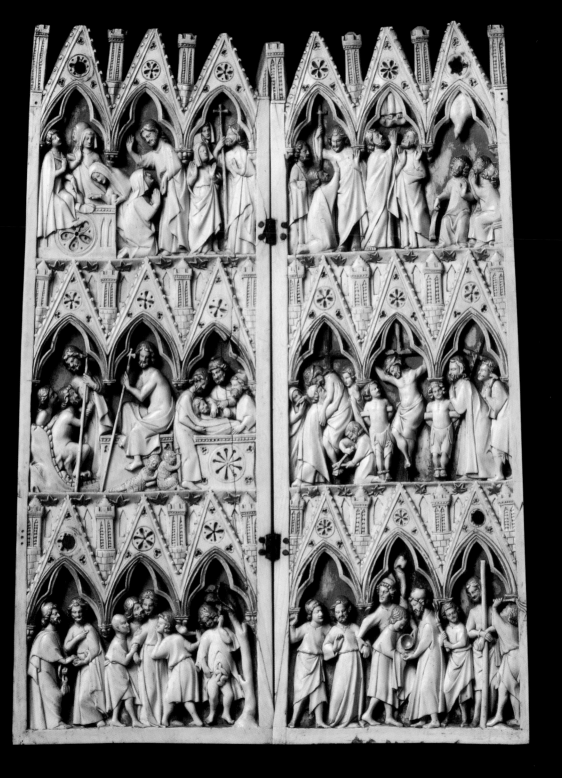

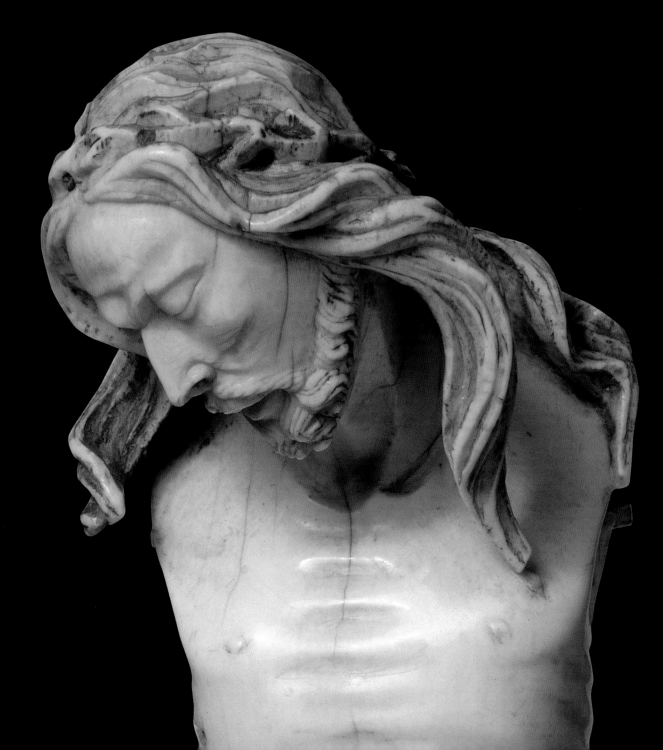

FIGURE OF THE CRUCIFIED CHRIST

By Giovanni Pisano (about 1250–after 1314)

Italian (Pisa); about 1300

Ivory, painted and gilt

V&A: 212–1867; h. 15.3 cm

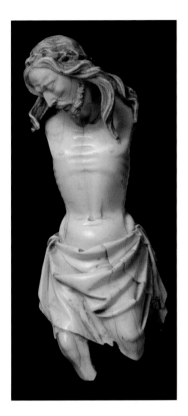

 THIS STRIKING FRAGMENT is all that remains of what was probably a small altar cross. Its style is that of Giovanni Pisano, probably the most talented sculptor of the years around 1300. Giovanni, son of the Pisan sculptor Nicola, is known to have worked in stone, wood, gold and ivory. He combined an interest in the ancient world with a knowledge of the style and iconography of northern Gothic art. This is evident both in the selection of material – ivory was an unusual choice for sculpture in Italy at this date – and in the way this figure maintains a tension between naturalism and expression, pathos and monumentality. The whiteness of the ivory is highlighted by a very sparing use of colour and gilding.

Giovanni and his workshop executed a number of wooden crucifixes for churches in Tuscany, and at least one of these is known to have been used in penitential Easter processions. It is possible that this ivory figure was used in a similar way, but its primary purpose would have been as an altar furnishing. Ivory crucifixes are sometimes recorded in church inventories of the period, and just such an item is listed in the Pisa Cathedral inventory of around 1313. Giovanni produced monumental sculpture in Siena, Pisa and Pistoia, and it is likely that this figure was made for an altar in one of the churches of these cities. GD

THE VIRGIN AND CHILD

French (Paris); about 1320–30

Ivory

V&A: 4685–1858; h. 40.6 cm

THE POPULARITY OF THE VIRGIN MARY among Christian worshippers of the thirteenth and fourteenth centuries was encouraged by accounts of miracles that presented the Mother of God as a humane and forgiving figure, as well as a military ally of considerable might. Ferdinand III of Castile (d. 1252) attributed his victories against the Arab rulers of Cordoba and Seville to a small statue of the Virgin and Child that he carried with him into battle.

This statuette probably had a less turbulent history. By the end of the thirteenth century Paris was renowned as a European centre for ivory carving, and such figures were produced to satisfy demand from wealthy and royal customers. Their demand was also spurred by the exotic allure of ivory, imported from East Africa and distant India. Once purchased, these statues probably stood on an altar in a private chapel, or in a bedchamber. The smiling Virgin holding her inquisitive baby son would have encouraged the devout owner to consider the human qualities of these figures, thereby reinforcing the intimate and personal nature of Christian worship in this period. Gilding and painting, now rubbed away, would have enhanced the vivid humanity of this devotional statue.

This representation of the Virgin and Child is also governed by symbolic traditions. Although now lost, the lily that Mary originally held in her right hand signified her virginal state when her son was conceived by the Holy Spirit. The crown on her head distinguishes her as Queen of Heaven. Even the ivory of the statue itself is significant. Its luminous, white qualities were appropriate reflections of Mary's purity, while medieval churchmen used biblical texts to layer extra religious significance onto this material. Thus King Solomon's ivory throne was linked to the symbolic perception of the Virgin herself as a precious ivory seat of Divine Wisdom. KK

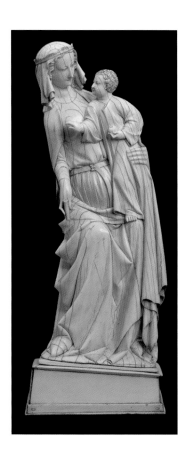

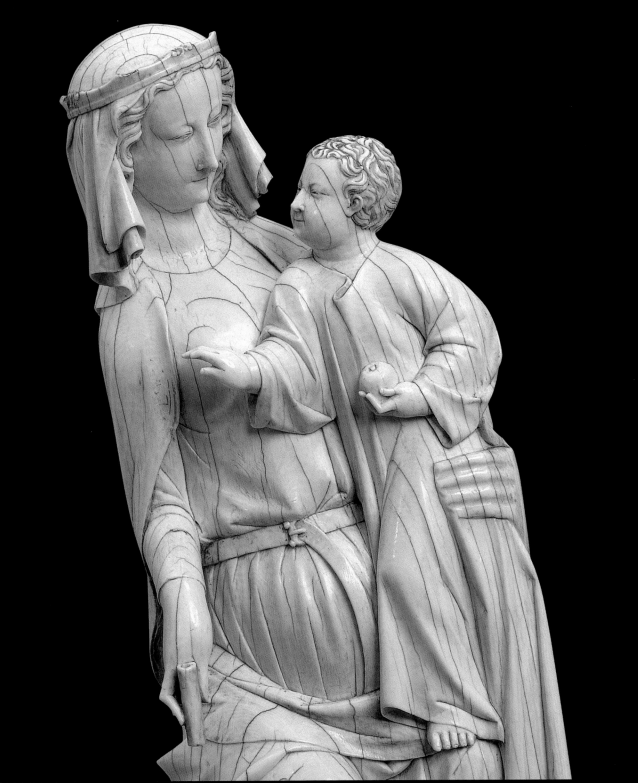

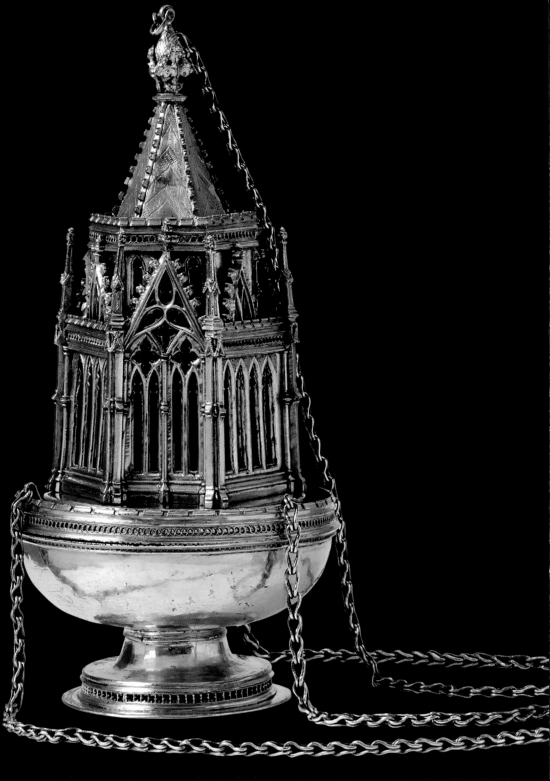

CENSER AND INCENSE BOAT

English (probably London or East Anglia);
about 1325 (censer) and 1350 (incense boat)

Silver-gilt (censer); silver and parcel-gilt (incense boat)

V&A: M.268–1923; h. 27 cm / V&A: M.269–1923; h. 12.5 cm

THESE OBJECTS GIVE a rare sense of what sophisticated ecclesiastical metalwork looked like in medieval England. The censer is one of only two surviving English Gothic censers, and the only one in precious metal. Like the Soissons diptych (no. 15), it demonstrates eloquently how architectural forms were miniaturized and taken over for liturgical and devotional objects. The incense boat is the only surviving silver example from England. Censers were standard items of church metalwork and were used during various ceremonies, such as the Mass, processions, blessings and the performance of the last rites. Incense, which was stored in the boat-shaped vessel, was placed on hot coals within the censer. When the censer was swung on its chains, aromatic smoke was given off. Inventories reveal that while churches often possessed many chalices, they usually only had one or two censers.

The censer and incense boat, which were not made as a pair, were discovered in 1850 in the bed of Whittlesey Mere, Huntingdonshire, when it was drained for conversion to farmland. The incense boat is decorated with rams' heads, which are almost certainly a rebus (a punning symbol) for 'Ramsey'. The Benedictine abbey of Ramsey was only about seven miles away from the discovery site. It is possible that the objects were thrown into the Mere during the Dissolution of the monasteries in the sixteenth century, although documents indicate that the monks of Ramsey accepted the Dissolution with equanimity. An alternative explanation is that these objects were lost during a boating accident, a strong possibility given that most travel through the Fens at this time was by boat. GD

THE VIRGIN WITH THE DEAD CHRIST

Southern Netherlandish; about 1430

Alabaster

V&A: A.28–1960; h. 39.7 cm; given by Sir Thomas Barlow

 SMALL SCULPTURES OF THE VIRGIN with the Dead Christ supported on her lap became popular objects of devotion from about 1300 onwards. This type of group was known as the Pietà (or *Vesperbild* in German), and acted as an aid to intense meditation and prayer. The affective piety that these images encouraged, both in the home and the convent, was articulated by a succession of late medieval writers, especially in Germany. A sixteenth-century English description of one such image sums up the tenderness with which they were observed: 'there was a fair image of our Blessed Lady, having the afflicted body of her dear son, as he was taken down, off the Cross, lying along in her lapp, the tears, as it were, running down pittyfully upon her beautiful cheekes, as it seemed, bedewing the said sweet body of her son, and therefore named the image of our Lady of Pitty'. It is clear that such sculptures were particularly intended for and venerated by women, who would have shared the Virgin's maternal grief.

In northern Europe sculptures of the Pietà were made in large numbers during the fifteenth century, in a variety of materials and for different markets. This particular example is one of the finest, and may be attributed with confidence to the sculptor who executed the alabaster figures for an altarpiece once in the church of Santa Maria delle Grazie in Rimini-Covignano (now in the Liebieghaus Museum in Frankfurt am Main). Because of the original location of his most important surviving commission he is now known as the 'Rimini Master', but it is obvious that he was working in the North, probably in the southern Netherlands. His work must have been widely in demand, and relates closely to contemporary paintings by Rogier van der Weyden and the so-called Master of Flémalle. PW

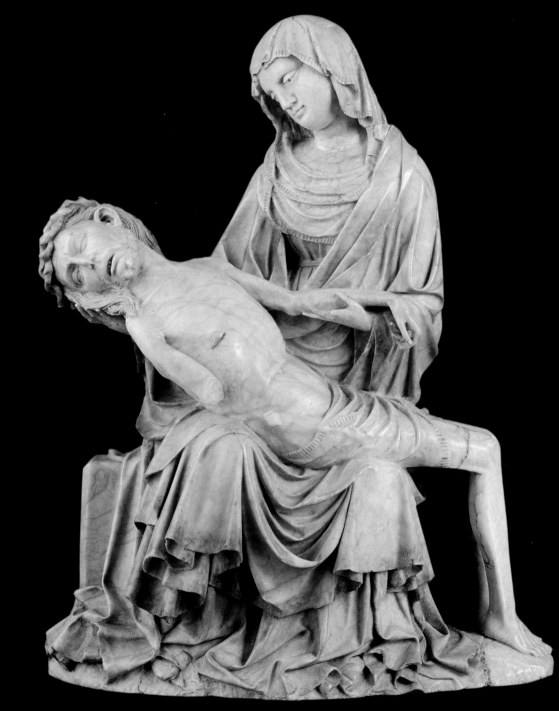

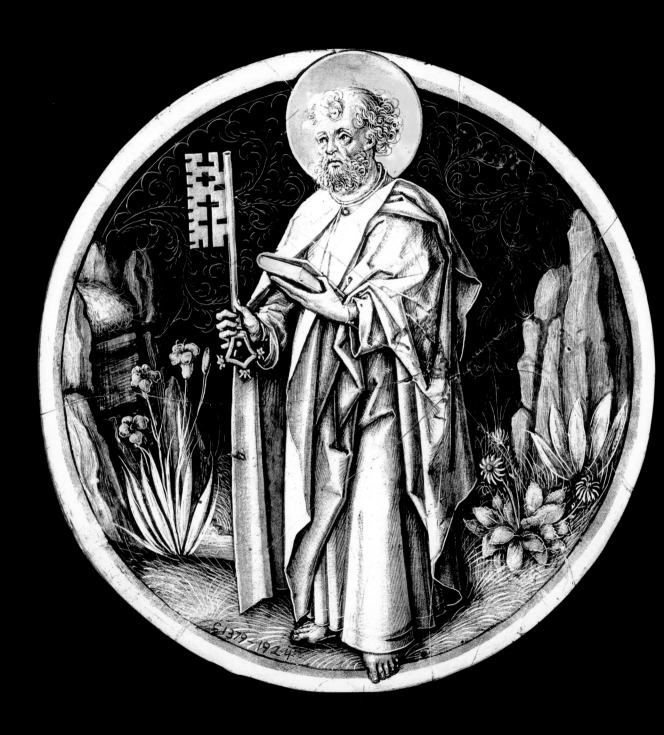

ST PETER

German (Middle or Upper Rhine); about 1480–85

Stained and painted glass

V&A: C.1379–1924; diam. 17.8 cm

 STAINED GLASS WAS ONE OF the principal media for illustrating Christian narrative in the Middle Ages (see no.14), but it was also employed for single devotional images in both domestic and ecclesiastical settings. In the late medieval period, small, mostly round panels were commonly inserted into 'trellises' of clear glass quarries (either lozenge-shaped or round) to embellish and enliven interiors. Roundels were sometimes devoted to biblical, allegorical or moralizing scenes, but their small scale especially suited the depiction of single figures.

This roundel of St Peter is a superb example of painting on glass, with a subtle use of etched decoration and silver (yellow) stain in the background and details. It is identical in style to another roundel showing St John the Baptist in the Museum Schnütgen in Cologne, and both have been related to the work of the so-called 'Master of the Housebook', a painter and engraver active in the area of the Middle Rhine Valley in the years just before 1480. The figures are based on those found in the engravings of the celebrated artist Martin Schongauer and share the fine detail and remarkably precise drawing of their models. Always intended to be seen at close quarters, they were probably commissioned to decorate a private chapel or hall. PW

RELIQUARY BUST OF ST ANTIGIUS

Northern Italian (Brescia); about 1505–10

Copper, silvered and gilt

V&A: M.52–1967; h. 53 cm, w. 44.4 cm

 THIS CAREFULLY WORKED COPPER-GILT bust is hollow. As the main inscription makes clear, it would have contained the head of Antigius, a saint of mysterious origin whose relics had been stored in the monastery of SS Faustino e Giovita in Brescia since the ninth century: C(aput) S(ancti) ANTI/GII EPI(scopi) BRIX(ae) ('The head of St Antigius, Bishop of Brescia'). A second, smaller inscription to the sides of the base explains that the bust was commissioned by the monks themselves, but it is unclear whether it was to contain only the skull of Antigius or whether other body parts were included too. An ascription to the Brescian goldsmith Bernardino dalle Croci (documented 1486–1528) has recently been made.

A medieval piece of historical wishful-thinking had included Antigius among the bishops of Brescia, and the gilded stole round his shoulders and silvered cope patterned to imitate velvet identify him here as such. Damage to the head of the bust, meanwhile, suggests the loss of a mitre that he may originally have worn, and the jewelled morse (clasp) that fastened his cope is now missing; it has been suggested that a morse in the Museum's possession (V&A: 496–1897) originally belonged to the bust, but this is far from certain. The five scenes on the stole depict not stories from the life of Antigius – as might be expected – but events from Christ's Passion.

Reliquaries like these were doubly valuable, both for their workmanship and for what they contained. When displayed to crowds of the faithful on the saint's feast day, worshippers would pray for the protection or aid of the saint and be allowed to kiss the reliquary – but not touch the relics themselves. That rare privilege was reserved for high-ranking and wealthy personages. KK

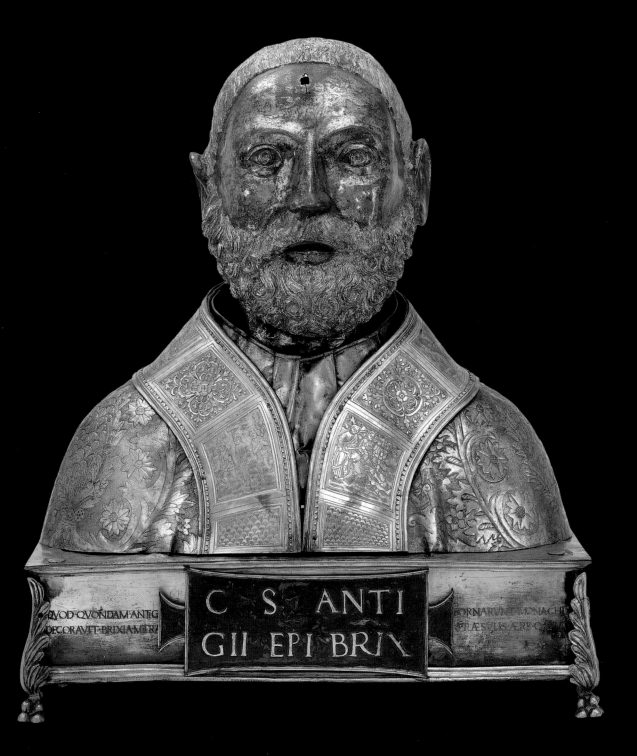

C S ANTI
GII EPI BRIX

QVOD QVONDAM ANTIG
DECORAVIT BRIXIAM ER

ORNARVM MONACH
PRÆSVLIS ÆRE C

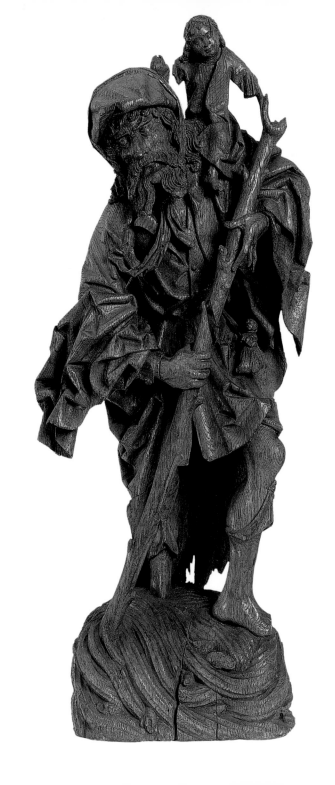

ST CHRISTOPHER

Eastern Netherlandish (Limburg); about 1520

Oak

V&A: 374–1890; h. 56.5 cm

 ST CHRISTOPHER, THE PATRON SAINT of travellers, is shown here in typical pose, carrying the Christ-Child on his shoulders across the river. The story of St Christopher was one of the most popular of the Middle Ages and the Renaissance, especially in the north of Europe, exemplifying the virtues of strength and determination in the service of Good. Images of the saint abounded in churches, usually near the door, and prayers were said before them to ensure his protection during the day (see p.40).

The statuette has been attributed to the workshop of the so-called Master of Elsloo, a Netherlandish sculptor active in the area around Roermond in the first decades of the sixteenth century. As with the contemporary Virgin and Child by Veit Stoss (no.8), the sculptor has here taken the opportunity to demonstrate his great skill in carving fluttering drapery and capturing dramatic movement. The wood from which the sculpture is carved – oak – is more intractable and roughly textured than the dense and tightly grained boxwood of the Virgin and Child, but the sculptor has risen to the challenge with startling success. It is likely that this sculpture was commissioned by its owner, rather than bought ready-made, and there is the possibility that the small praying figure carried in the bag attached to the saint's belt represents that person. PW

THE SECULAR WORLD

ALONGSIDE ARTISTIC PRODUCTION for the Church there was, of course, a constant output of objects intended for the home, for personal adornment and for the establishment of corporate and dynastic identity. Throughout the Middle Ages and Renaissance – and indeed from before classical antiquity – jewellery was one of the principal means of demonstrating secular status and wealth. Superb examples of intricate workmanship are found from all periods between 400 and 1600, but only the two poles can be illustrated here. In their own ways they exemplify the artistic production of the eras from which they came: the love of pattern and minute inlay work of the Anglo-Saxons, and the splendid opulence and natural forms of International Mannerism (nos 24, 12). Complementary to the adornment of the body was the ability to keep it attractive, so the tools of beauty – combs, mirror cases and other items – also became increasingly beautiful themselves.

In fourteenth-century Paris especially, the production of ivory mirror cases took the form of a minor industry. Many of these circular reliefs show scenes of courtly love, reflecting the clientele for which they were destined and shedding light on the leisure activities of the upper class (right). Games of all sorts were played, especially board games of chess, backgammon and draughts, and it is clear that from the twelfth century onwards the best workshops were employed in their manufacture (no. 25).

With the growth in numbers of moneyed individuals in the Late Middle Ages, brought about through the loosening of feudal dominance, the expansion of cities and the rise of new manufacturing industries, there developed a wider interest in the construction of a clearly recognizable identity. Heraldry served a vital purpose in this connection as a vehicle for self-aggrandisement, its use spreading from banners on the battlefield to the objects and buildings owned by the gentry (nos 26–7, 31–2). The 'rise of the individual' was also marked by the evolution of the portrait, with a combination of a new interest in self-image and advances in painting techniques in the fifteenth century leading to representations of startling verisimilitude (no. 33).

An interest in temporal matters – 'the world of the intellect' – also encouraged the development of knowledge about the past and a desire to re-create the refined milieu of classical learning. In Italy, small groups of scholar-collectors acquired Roman bronze statuettes and discussed classical texts, and in due course these sculptural models were copied and adapted by fifteenth- and sixteenth-century

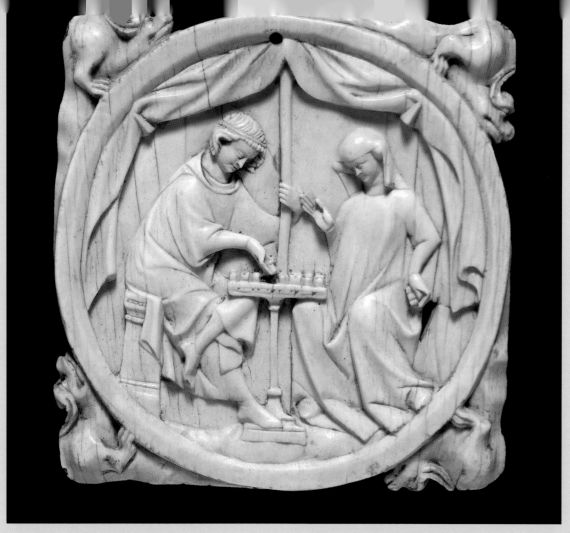

Mirror case showing a game of chess; ivory; French (Paris), about 1300–20. V&A: 803–1891.

sculptors and goldsmiths and were more widely disseminated (no. 30). Themes of classical inspiration also entered the decorative vocabulary of other art forms so that, for instance, legendary stories from antiquity were repeatedly employed for the decoration of maiolica plates (nos 31–2). In addition to this interest in the past, many craftsmen and their patrons energetically pursued scientific enquiry, a curiosity that led to the development of new techniques such as soft-paste porcelain (no. 34). Leonardo da Vinci is recognized as the epitome of the Renaissance Man, combining a constantly questioning intellect with brilliant artistic skills (no. 35): although unparalleled, his concerns exemplify the climate of humanistic enquiry that flourished in Renaissance Italy. PW

LEAF OF THE CONSULAR DIPTYCH OF ANASTASIUS

Byzantine (Constantinople); 517

Ivory

V&A: 368–1871; h. 36.2 cm, w. 12.7 cm

SECULAR IVORY CARVINGS make up a large proportion of the output of the Early Christian workshops, and of these the majority are consular diptychs, presented by the consuls – among the highest-ranking positions in Rome and Constantinople – as they came to office. Nearly 50 examples survive from the years 406–540, and a good number show the consul in the act of opening the games, as here. The importance of the consular diptychs lies not just in the fact that they reveal a glimpse of the splendour of the Early Byzantine court, but also in that they are all securely datable to the year of the consul's office and thus provide a framework for the chronology of other works.

This panel shows Flavius Anastasius, consul at Constantinople in 517, and another panel once in Berlin would have completed the diptych: this was lost in the Second World War. The consul is represented at the games, his right arm raised to drop the *mappa circensis* (the ceremonial napkin or handkerchief) and start the festivities. The busts above show the Emperor and Empress, and on the left a bare-headed figure who probably represents the other consul. Below, small figures process into the circus and are involved in other activities, including one bald man who – in an act of comical endurance – has a crab attached to his nose. An eighteenth-century engraving illustrating the leaf before it was broken at the bottom right shows a further man, his hands bound behind his back, bending down to encourage another crab to pinch his nose.

Like the Symmachi panel (no. 1), the Anastasius diptych was converted to Christian use at a later date, a transformation which probably explains such ivories' survival. It was kept in Liège Cathedral until the French Revolution, when the treasury was broken up. PW

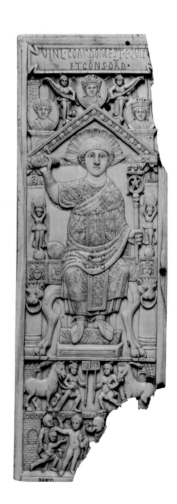

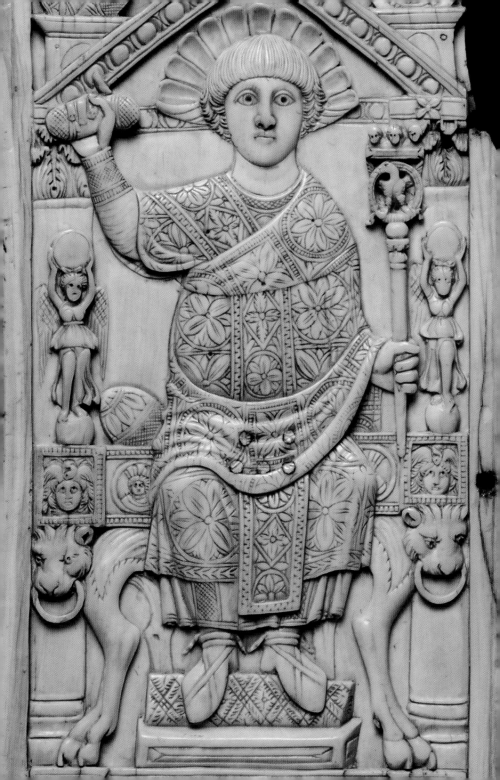

TWO ANGLO-SAXON BROOCHES

Anglo-Saxon; 7th century

Silver set with gold filigree, garnets and blue glass-paste inlay

V&A: M.110–1939; diam. 4.9 cm; found at Faversham

Gold and silver with garnet inlay, on a backing of copper and compositions

V&A: M.109–1939; diam. 7.7 cm; found at Milton, near Abingdon, in 1832

JEWELLERY OF A VERY HIGH QUALITY was produced by Germanic peoples during the late sixth and early seventh centuries, reflecting a number of traditions and cultures. Both of the examples illustrated here are indicative of the taste for brightly coloured brooches in the Anglo-Saxon kingdoms. Faversham in Kent, where the smaller brooch was found, was probably an important centre of production for jewellery of this type.

The materials used to make the brooches are testament to international trade links. The red garnets, for example, may have come from Sri Lanka, and scientific analysis has recently demonstrated that some white seashells used to create inlays originated in the Mediterranean. Twisted gold-wire filigree was frequently used to create distinctive interlace patterns. The polished garnets and areas of gold sheet would have gleamed and flashed when the jewels were worn. Brooches like these had pins attached to the back and were worn by women as de-luxe cloak fastenings.

The brooch from Milton is one of a pair (the other is in the Ashmolean Museum in Oxford) said to have been found on the breast of a skeleton in 1832. The status of individuals was reflected in the richness and range of the goods that were buried with them. The decoration of the Milton brooch features a cross of garnet inlay, but this does not necessarily relate to Christianity or reflect the religious beliefs of the owner. SF

TWO TABLEMEN

German (Cologne); about 1150

Ivory

V&A: 374–1871; diam. 6.6 cm / V&A: A.3–1933; diam. 7.3 cm;

the latter bequeathed by Mr Henry Oppenheimer through the Art Fund

GAME PIECES OF THIS SORT are sometimes described as draughtsmen, but it seems more likely that they were used for playing 'tables' (a form of backgammon), a pastime that is known to have been popular among the nobility. Boards and pieces were taken on the Crusades, and a playing board and two full sets of pieces have been excavated in Gloucester. These two pieces are unusual at this date in the north of Europe for having been carved from elephant ivory, rather than the more common walrus ivory. It is hard to identify the subjects depicted on them with certainty, but several game pieces of this date depicted the feats of Hercules, or his biblical parallel Samson, and it is likely that these too represent his labours. The figure of the man struggling with a snake has certainly been inspired by classical antecedents. The figure with sword and shield in combat with another snake-like creature may well represent Hercules and the Hydra. The carving of the pieces in deep-sunk relief with a high border enabled them to be easily stacked one on top of the other.

During the twelfth century Cologne was an important centre for the production of metalwork and carved ivories, for both sacred and secular uses. The tableman with Hercules and the Hydra is carved in the distinctive 'pricked' style employed on a number of religious walrus-ivory reliefs, where the surfaces and edges of draperies are enlivened with small dots. GD

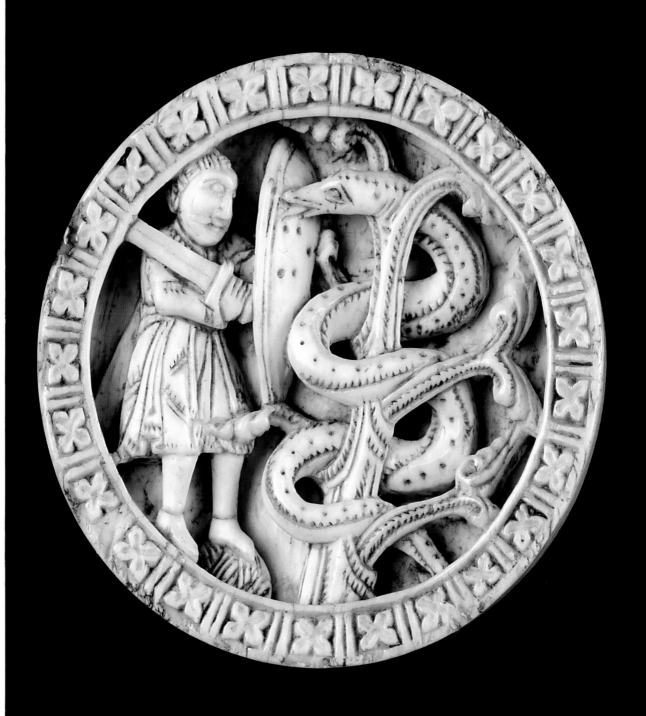

WILD MAN AND WOMAN SUPPORTING THE ARMS OF KYBURG

Attributed to Lukas Zeiner (active about 1480–1510)

Swiss (Zurich); about 1490

Stained and painted glass

V&A: C.9:1–1923; h. 29.8 cm, w. 25.2 cm

TO MANY, STAINED AND PAINTED GLASS is most often associated with religious spaces, with the great windows of the cathedral or parish church. However, there was also a desire – especially in the Late Middle Ages and the Renaissance – to employ it in the secular realm. Its bright colours, the range of hues that could be used, and the ease of dividing the composition with lead lines made it especially appropriate for the depiction of coats of arms and heraldic 'achievements' (which usually included the shield, supporting figures at the sides and a crest above). Heraldic glass is often to be seen in the halls of great houses, in private chapels, and was commonplace in town halls and guild halls: it commemorated illustrious families and post-holders and often helped to establish a visual history of dynasties, towns and secular organizations.

Heraldic panels were particularly popular in southern Germany and Switzerland in the fifteenth and sixteenth centuries, and continued to be produced well into the seventeenth. Perhaps the most accomplished Swiss glass painter in the years around 1500 was Lukas Zeiner of Zurich, who specialized in the production of exquisite small panels for the secular market. This panel shows the arms of the county of Kyburg, north-east of Zurich, supported by a Wild Man and Woman. Wild men were often shown supporting heraldic shields at this date: they represented strength and potency and symbolized freedom, so were thought to be particularly apt in the context of civic virtue. PW

WINGED PUTTO WITH FANTASTIC FISH

By Donatello (about 1386–1466)

Italian (Florence); about 1435–40

Bronze with traces of gilding

V&A: 475–1864; h. 40.5 cm, w. 40.4 cm

 THIS SMALL BRONZE was created as part of a wall-fountain; the water was piped through a hole in the back of the figure and would have sprayed from the mouth of the fish and the putto's penis. Traces of gilding, an expensive addition to the already costly bronze, remain on the wings and fish. The subtlety of modelling was revealed by the removal of layers of corrosion and wax in 1977. Similarly, at that time what was thought to be a rocky base on which the boy stood emerged as a tortoise, an emblem of the powerful Medici family of bankers and political leaders in Florence. It is therefore possible that the figure was designed for one of their villas in the nearby Tuscan countryside, where they would go to escape the heat of the city, to relax and to entertain.

Donatello, the most gifted and innovative sculptor of his age, was described by the sixteenth-century artist and biographer Giorgio Vasari as 'friend and servant' of the Medici. This winged putto or *erote,* inspired by the sculpture of classical Rome, stands in a *contrapposto* pose – his weight borne on one leg – as he gazes down on the viewer. His expression could be read as a mischievous smile, especially when seen in conjunction with the play of water from the penis striking a (now missing) whirligig, which must originally have been clasped in the clenched right hand. Vasari saw a similar device made 'in the manner of a butterfly' held by a later figure of Mercury (now in the Fitzwilliam Museum, Cambridge) on a fountain at the Medici palace, and described how the water made it spin. The present classicizing, yet playful figure would have appealed to Donatello's Medici patrons, demonstrating their educated taste to admiring guests. PM

THE MARTELLI MIRROR

Possibly by Caradosso Foppa (1452–1527)

Italian (Milan); about 1495–1500

Bronze with gold and silver

V&A: 8717–1863; diam. 19.5 cm

 THIS FINELY WORKED RELIEF decorates the back of a separate polished-steel mirror. Profile figures of an aged satyr and a bacchante face each other beneath a herm (a tapered pedestal that merges with a figure at the top) representing the ancient Greek fertility god, Priapus. The bacchante expresses milk from her breast into a rhyton, or ceremonial drinking cup, terminating in a griffin, possibly a reference to the Martelli family, from whom the mirror was eventually bought in 1863. A prominent but mysterious disembodied head rests on the draped moulding beneath. The Latin inscription at the base, meaning 'nature encourages what necessity demands', confirms that the relief is an allegory of procreation.

The relief was traditionally attributed to the leading Florentine sculptor, Donatello. However, the exquisite surface finishing suggests that it is more likely the work of a goldsmith. A cutting from a document found inside connects the bronze with Milan, and has led to an attribution to the goldsmith Caradosso, who worked there between 1475 and 1505. His art remains elusive, however, as so many of his works are lost.

Metal mirrors, though not very effective, were common at this date before small glass mirrors became more widespread in the sixteenth century. The design on the mirror back is largely based on classical gems, at least one of which, showing the bacchante, was in the collection of Lorenzo de' Medici. The elaborate iconography also relates to neo-Platonic debates then current in the Medici circle, which included their fellow bankers, the Martelli. The somewhat ribald imagery can be associated with marriage and the desire to bear healthy sons. The mirror was therefore probably an intimate and expensive wedding gift, most likely for a member of the Martelli family. PM

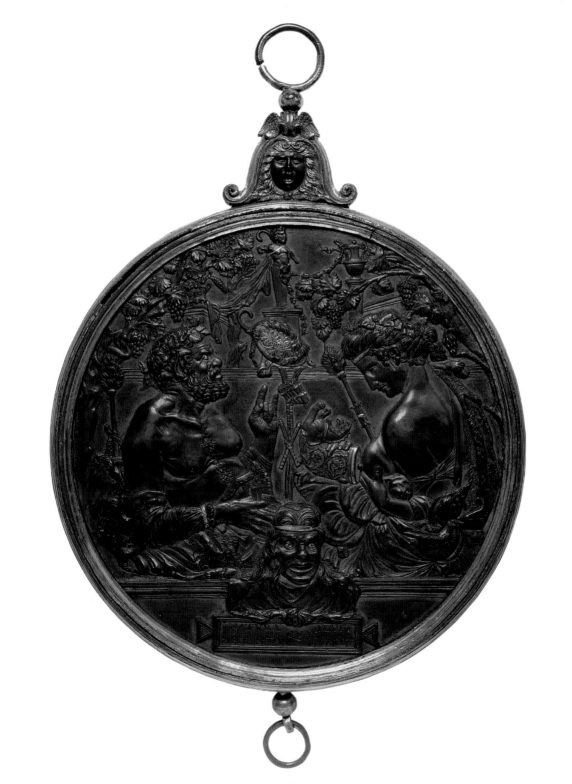

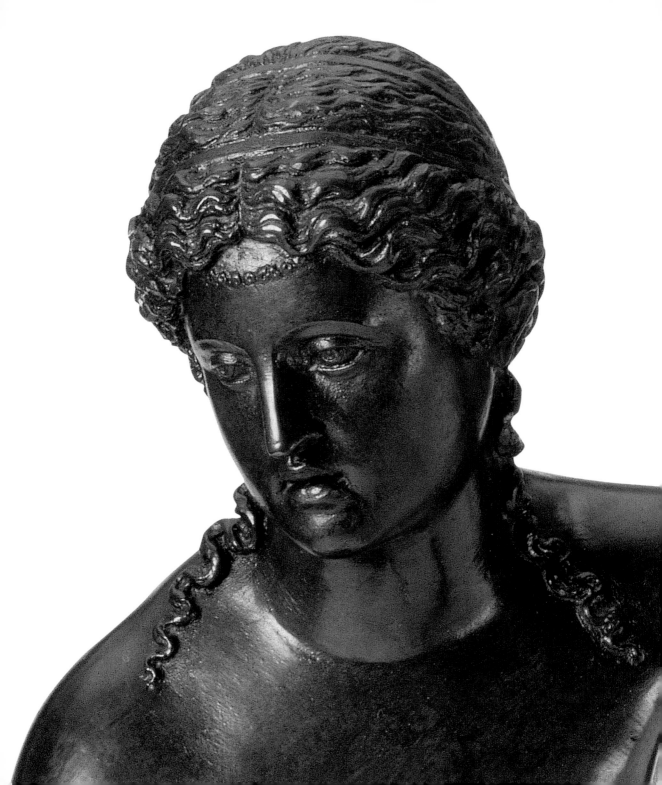

ATROPOS

By Pier Jacopo Alari-Bonacolsi, called Antico
(about 1460–1528)
Italian (Mantua); about 1500
Bronze

V&A: A.16–1931; h. 29.5 cm; bequeathed by Sir Otto Beit

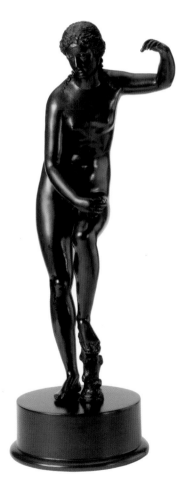

 THIS FINELY DETAILED BRONZE represents one of the Three Fates, the spirits who in Greek and Roman religion were believed to determine man's destiny. A silk cocoon nestles in her raised left hand, and her right holds the remains of a pair of scissors with which she cuts the (now missing) thread of life. This classicizing figure, while not based on a precise prototype, is typical of the work of the aptly named Antico, reflecting the courtly taste of his patrons, the Gonzaga lords of Mantua.

The cocoon, or *bozzolo* in Italian, is doubtless a pun referring to the Gonzaga castle at Bozzolo, and the statuette was probably made for the cultivated collector Bishop Ludovico Gonzaga during his stay there in 1498–1500. Antico developed a sophisticated method of replicating small bronzes by using moulds taken from his original models. In 1519 he supplied copies of Ludovico's bronzes to the notorious Isabella d'Este, wife of the Marquess Gianfrancesco Gonzaga (see also no. 32). Among these was another Atropos (now in the Kunsthistorisches Museum in Vienna), although Isabella's copy lacks some of the intricate details.

Such elegant statuettes were ideal for handling and admiring at close quarters, but they were also often placed on shelves or architraves. In 1501 Isabella commissioned a *Spinario* (a boy plucking a thorn from his foot) from Antico to be set above a doorway in her *camerino* (small room). She was so delighted with it that she sent one of her velvet dresses as a gift to Antico's wife, and two years later commissioned a pendant figure for another doorway. The letters of Ludovico and Isabella reflect the esteem in which they held 'Antico, sculptor, our courtier', and emphasize the status acquired by the artist. PM

BOWL WITH THE ARMS OF MATTHIAS CORVINUS AND BEATRIX OF NAPLES

Italian (Pesaro); 1476–90

Tin-glazed earthenware, painted

V&A: 7410–1860; diam. 46.8 cm

THIS LARGE BOWL is one of two surviving pieces from the earliest-known set of ceramic tableware made in Italy for a foreign ruler. In 1476 Matthias Corvinus, King of Hungary (elected 1458, died 1490), married his second wife Beatrix (1457–1508), daughter of Ferdinand I of Naples. Their arms (his on the left, hers on the right) are linked by a crown, symbolizing their royal marriage.

The significance of the occasion commemorated by this bowl suggests that we should read a special symbolism into the choice of subject matter for the central image. The naked children, gathering and sorting fruit from an orange tree, imply fertility and fruitfulness appropriate to the celebration of a marriage. However, this scene appears on other dishes of the period and is entirely suitable for a dining context. The climbing children probably represent the stern observation delivered by St Paul in his second epistle to the Thessalonians that 'if any would not work, neither should he eat'. A Florentine dish from around 1480, now in the V&A, is explicit: it shows two children clambering up a tree and the legend *E no se po mangiare senza fatiga* ('One cannot eat without toil').

The early date at which this service was exported implies the growing prestige of Italian ceramics and the taste for them in the courts of Europe. Beatrix herself was said to prize earthenware even more highly than silver vessels. Despite the pristine condition of many pieces, occasional references in documents suggest such vessels were used for dining. The sheer variety of forms and sizes which survives also implies this was tableware that did occasionally contain food. KK

BOWL WITH THE ARMS OF GONZAGA IMPALING ESTE

By Nicola da Urbino (active 1520–38)

Italian (Urbino); probably 1524–5

Tin-glazed earthenware, painted

V&A: C.2229–1910; diam. 27.5 cm; Salting Bequest

 THIS WIDE-RIMMED BOWL is doubly significant for the history of Renaissance art and patronage. The arms and mottoes belong to Isabella d'Este, Marchioness of Mantua and widow of Gianfrancesco Gonzaga (d. 1519). An enthusiastic patron of the arts, Isabella embraced the Renaissance fashion for classical learning despite her ignorance of Latin (see also no. 30). Her tutor, the scholar Mario Equicola, probably inspired the motto *nec spe nec metu* ('without hope and without fear'), painted here on the balustrade, which suggested Isabella's ideal perception of herself. The Roman numerals, meanwhile, make up the number 27 or, as Isabella would have read it, *vinti sette*, which puns on the Italian phrase 'you are defeated'.

The style of painting and use of colour have led to an attribution of the bowl's design to Nicola da Urbino, one of the first ceramic painters to specialize in this type of decoration. Known as *istoriato* ('with a story'), the biblical and classical scenes depicted on these wares were mostly derived not from the artist's imagination, but from woodcuts illustrating well-known editions of these texts. Painters might combine several different sources: some of the figures on this bowl suggest that Nicola had before him a copy of Ovid's *Metamorphoses*, published in 1497.

The scene on the bowl depicts Hippolytus, dressed as a fashionable Renaissance gentleman, being pushed away by his stepmother Phaedra (in equally contemporary dress). She has falsely accused him of trying to seduce her. The figures on the left, dressed in Roman costume, are perhaps Phaedra's husband Theseus, and Hippolytus riding into exile. Twenty other pieces survive from this service, mostly showing scenes from ancient mythology. KK

PORTRAIT OF JACQUES DE GENOUILLAC

French (Limoges); 1540–46

Painted enamel and gilding on copper

V&A: 8415–1863; h. 18.3 cm, w. 14 cm

 JACQUES DE GENOUILLAC (1465–1546), Lord of Assier (southern France), soldier, diplomat and patron of the arts, served three successive kings of France and is the subject of this small portrait of painted enamel. At the time this image was produced, he had become Superintendent of Finances under Francis I and perhaps also Governor of Languedoc. His luxuriant, square-cut beard is not fashionably dyed and his black clothing, current among the French nobility of the mid-sixteenth century, carries no ostentatious jewels or devices to signal his identity. Only comparison with known drawings has established this as his portrait, which suggests it was commissioned by Genouillac as a gift to a close friend who would have needed no identifying symbols or inscriptions. Although the exact use and display of such enamelled portrait plaques remain obscure, household inventories list them among the valuable objects kept in private rooms. It seems they were sometimes framed, and sometimes set into panelling or furniture.

The portraitist was almost certainly Léonard Limosin, a member of a well-known artistic dynasty that produced painted enamels in Limoges. Although Leonardo da Vinci had praised this technique as more durable than panel, canvas and stucco painting, the Limoges painted-enamel workshops actually enjoyed their Europe-wide fame for little more than a century, after about 1460. Limosin, born around 1505, was also a panel painter and engraver, but his enamelling skills brought him in 1534 to the Fontainebleau court of Francis I. His work was particularly appreciated for the originality of its compositions, in an age when many decorative artists preferred to rely for their subject matter on pre-existing design sources such as prints. KK

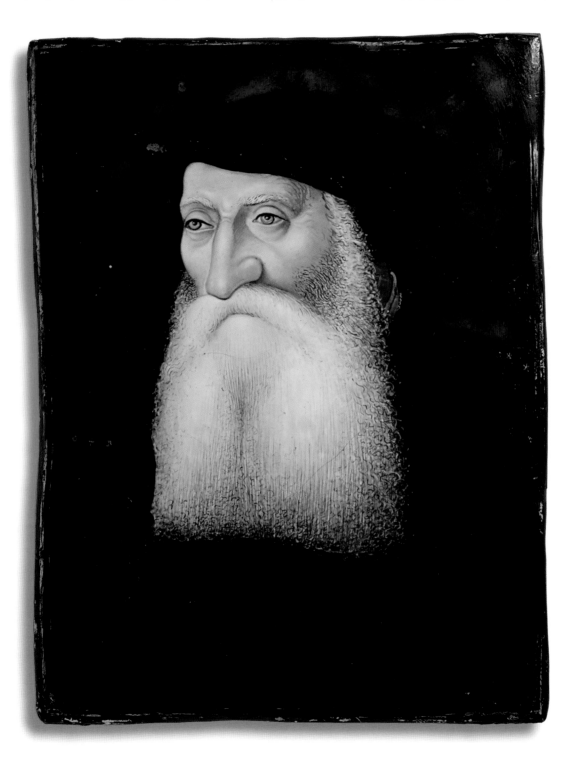

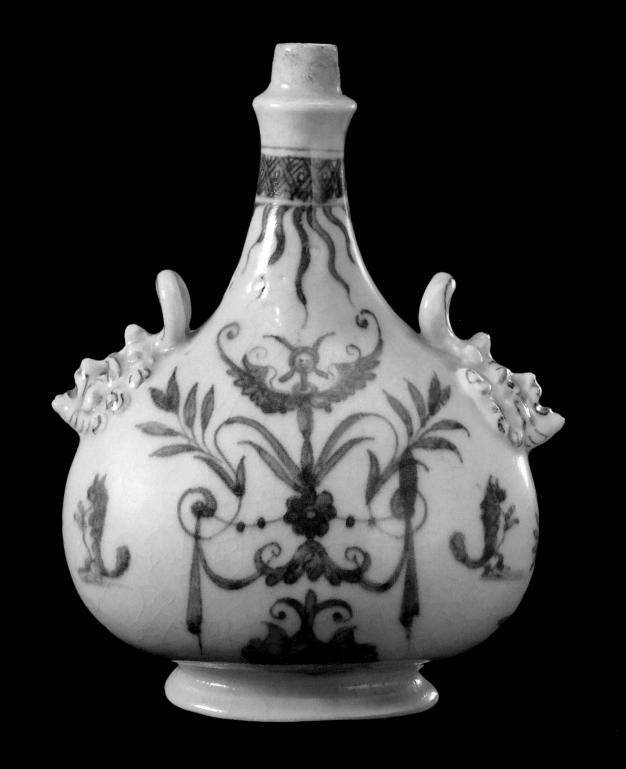

MEDICI FLASK

Italian (Florence); about 1580

Soft-paste porcelain with cobalt underglaze

V&A: C.2301–1910; h. 19.7 cm; Salting Bequest

 THE WORD 'PORCELAIN' was coined by the thirteenth-century traveller Marco Polo, who compared the translucency and hardness of certain Chinese ceramics with that of the cowrie shell (*porcelle* in Italian). This flask – termed a pilgrim flask because its shape is derived from the humbler travelling vessels commonly taken on pilgrimage – is one of only 60 surviving pieces that testify to sixteenth-century Italian attempts to re-create the Chinese porcelain imported into Europe during this period. All failed. Renaissance ceramicists did not realize their formulae lacked a vital ingredient, China-stone (*petuntse*). Thus, while their combination of glass and fine white clay produced a ceramic with a glassy, white surface, Italian potters' wares failed to achieve the translucent quality of the Chinese pieces.

Efforts at imitation seem to have begun in Venice, itself a centre for the trade in oriental ceramics, but these met with limited success. None of these early attempts survives, however. The high proportion of pieces bearing the device of Grand Duke Francesco I de' Medici or an image of Florence Cathedral has led inevitably to the association between the Medici family and sixteenth-century experiments in porcelain production. Francesco spent the last decade of his life (about 1575–87) supporting this project: he was even said to have made pieces himself and distributed them as gifts to fellow European rulers. This flask may have been intended as such a gift, although it does not carry the Medici mark. It would have been displayed and admired, rather than used, and its decoration reflects the eclectic inspiration of its Italian painter. The symmetrical design on the front and back recalls classical Roman motifs, as do the moulded, mask-like handles, while the chrysanthemum and insect painted below them are Chinese in origin. The paired animals on the sides may be ermines, symbols of moral purity and Medici emblems. KK

LEONARDO NOTEBOOKS

By Leonardo da Vinci (1452–1519)
Italian (Milan), 1487–90 (Codex Forster 1^2);
(Florence), 1505 (Codex Forster 1^1)
Pen and ink, 55ff.

V&A: Forster MS 141/1; h. 14.5 cm, w. 11.5 cm, d. 2 cm

THE V&A POSSESSES THREE VOLUMES of Leonardo da Vinci's notebooks, bequeathed to the Museum in 1879 by John Forster. The three volumes actually contain five notebooks. The volume selected here, Codex Forster 1, is the largest and includes two notebooks. Codex Forster 1^1 was begun in Florence in 1505, shortly after Leonardo had begun work for a painting of the Battle of Anghiari in the Palazzo della Signoria, the centre of government of the Florentine Republic. Codex Forster 1^2 was compiled in 1487–90 when Leonardo was employed at the court of Duke Ludovico Sforza in Milan. It is not certain when the two notebooks were bound together in their current configuration.

Leonardo's notebooks reveal the extraordinary range of his interests and pursuits. His smaller notebooks provide evidence that he drew from nature outside the studio or workshop environment. Leonardo described himself as a 'disciple of experience' and wrote of the necessity of verifying knowledge through the senses. The two notebooks in this volume reflect his fascination with geometry and mathematics, and in focusing on a single area they differ from most of the other surviving notebooks. At the top of the right-hand page he has drawn a partially shaded dodecahedron. The drawings beneath this represent various stages in extracting a pentagonal face and converting it into a rectangular body or cube, enabling the area to be easily determined. The text is written in distinctive 'mirror-script'. As a left-handed writer, working with slow-drying inks and chalks that could be smudged easily, writing from right to left represented a practical approach rather than any desire for secrecy. SF

This page is written in mirror script (Leonardo da Vinci's notebook style) and is largely illegible as normal text. The page contains geometric diagrams including a dodecahedron and various polyhedra, along with extensive handwritten notes in reversed Italian script.

FURTHER READING

V&A Publications:

Ajmar-Wollheim, Marta and Dennis, Flora (eds), *At Home in Renaissance Italy* [exhibition catalogue], London, 2006

Baker, Malcolm and Richardson, Brenda (eds), *A Grand Design. The art of the Victoria and Albert Museum* [exhibition catalogue; with The Baltimore Museum of Art], New York, 1997

Campbell, Marian, *An Introduction to Medieval Enamels*, London, 1983

Jopek, Norbert, *German Sculpture 1430–1540. A Catalogue of the Collection in the Victoria and Albert Museum*, London, 2002

Kemp, Martin, *Leonardo da Vinci: Experience, experiment and design* [exhibition catalogue], London, 2006

Lightbown, Ronald W., *Mediaeval European Jewellery, with a catalogue of the collection in the Victoria and Albert Museum*, London, 1992

Marks, Richard and Williamson, Paul (eds), assisted by Eleanor Townsend, *Gothic: Art for England 1400–1547* [exhibition catalogue], London, 2003

Phillips, Clare, *Jewels and Jewellery*, London, 2000

Rackham, Bernard, with emendations and additional bibliography by J.V.G. Mallet, *Catalogue of Italian Maiolica*, London, 1977

Williamson, Paul, *An Introduction to Medieval Ivory Carvings*, London, 1982

Williamson, Paul, assisted by Peta Evelyn, *Northern Gothic Sculpture 1200–1450*, London, 1988

Williamson, Paul (ed.), *European Sculpture at the Victoria and Albert Museum*, London, 1996

Williamson, Paul (ed.), *The Medieval Treasury. The Art of the Middle Ages in the Victoria and Albert Museum* (3rd edn), London, 1998, reprinted 2002

Williamson, Paul, *Netherlandish Sculpture 1450–1550*, London, 2002

Williamson, Paul, *Medieval and Renaissance Stained Glass in the Victoria and Albert Museum*, London, 2003

Other selected volumes:

Alexander, Jonathan and Binski, Paul (eds), *Age of Chivalry: Art in Plantagenet England 1200–1400* [exhibition catalogue, The Royal Academy], London, 1987

Amico, Leonard N., *Bernard Palissy: In Search of Earthly Paradise*, Paris and New York, 1996

Barnet, Peter (ed.), *Images in Ivory: Precious Objects of the Gothic Age* [exhibition catalogue, The Detroit Institute of Arts], Princeton, 1997

Cormack, Robin, *Byzantine Art*, Oxford, 2000

Distelberger, Rudolf, Luchs, Alison, Verdier, Philippe and Wilson, Timothy, *The Collections of the National Gallery of Art – Systematic Catalogue. Western Decorative Arts, Part I: Medieval, Renaissance, and Historicizing Styles including Metalwork, Enamels and Ceramics*, Washington, DC, 1993

Enamels of Limoges 1100–1350 [exhibition catalogue, The Metropolitan Museum of Art], New York, 1996

Evans, Helen C. (ed.), *Byzantium: Faith and Power (1261–1557)* [exhibition catalogue, The Metropolitan Museum of Art], New York/New Haven and London, 2004

Evans, Helen C. and Wixom, William D. (eds), *Glory of Byzantium: Art and Culture of the Middle Byzantine Era, A.D. 843–1261* [exhibition catalogue, The Metropolitan Museum of Art], New York/New Haven and London, 1997

Jardine, Lisa, *Worldly Goods: A New History of the Renaissance*, London, 1996

Lasko, Peter, *Ars Sacra 800–1200* (2nd edn), New Haven and London, 1994

Nees, Lawrence, *Early Medieval Art*, Oxford, 2002

Syson, Luke and Thornton, Dora, *Objects of Virtue: Art in Renaissance Italy*, London, 2001

Welch, Evelyn, *Art and Society in Renaissance Italy, 1350–1500*, Oxford, 2000

Welch, Evelyn, *Shopping in the Renaissance: Consumer Cultures in Italy 1400–1600*, New Haven and London, 2005

Williamson, Paul, *Gothic Sculpture 1140–1300*, New Haven and London, 1995

Wilson, Timothy, *Ceramic Art of the Italian Renaissance*, London, 1987